7/11/94

Best Wishes

To Zoë

Ben Babolowsky

THE ART OF

Ben Babelowsky

◆ ◆ ◆

To Lise, Jeffrey, Jennifer and Jason

THE ART OF

Published by
The Ottawa Citizen
1101 Baxter Road
P.O. Box 5020
Ottawa, Ontario
Canada K2C 3M4

Creative Production:
ACART
Suite 600
171 Nepean St.
Ottawa, ON K2P 0B4

Prepress:
Hadwen Imaging Technologies

Friesen Printers

Printed in Canada

ISBN 0-9698908-0-X

◆ ◆ ◆

CONTENTS

◆　　◆　　◆

INTRODUCTION

◆　　◆　　◆

The *Ottawa Citizen* is pleased to present this collection of Ben Babelowsky's paintings to mark the newspaper's 150th birthday in 1995. During the many years that Ben served as the newspaper's energetic promotion and public relations director, he also had a thriving artistic career. Because many of his striking watercolors have been reproduced in the paper, Ben's art has become closely identified with the *Citizen*.

As we celebrate our 150-year roots in the community, it seems appropriate to feature the work of someone who has also put down deep roots since his arrival in Ottawa more than 30 years ago. Ben's love of the Ottawa Valley, from its bustling cities and towns to its historic mills and churches, is clearly reflected in his paintings. We believe that the affection for our area that is so obvious in Ben's work is a good symbol for the intimate relationship that develops between a newspaper and its community over 150 years.

The *Citizen*, like the community it serves, had modest origins. It was born as a weekly newspaper called The *Packet* in a building on muddy George Street in the rough, brawling lumber village of Bytown, Canada West. The year was 1845. Confederation was still 22 years in the future.

The founder was a local politician named William Harris, who used the paper to promote his political viewpoints. There were several other papers in Bytown in those early years pushing other political views. The *Packet* grew and evolved as it passed through the hands of several other owners over the next few decades. The name was changed to the The *Ottawa Citizen* in 1851 and it became a daily newspaper in 1865.

In 1897 it was sold to William Southam of Hamilton, founder of Southam Inc., which still operates the *Citizen* almost 100 years later. Two of his sons, Wilson and Harry, were sent to Ottawa to run the paper. They moved the *Citizen* to Sparks Street and installed a new press capable of printing 10,000 papers an hour. Business boomed and by 1903 they had built a new building on Sparks Street to house the growing newspaper.

The *Citizen* then …

The *Citizen* remained on Sparks Street through various additions and expansions for 70 years, until it moved to its present location on Baxter Road in November 1973. The current building was expanded, with the addition of a third press, through 1993 and 1994 to pave the way for conversion to full morning publication. As we approach the turn of the century, the *Citizen* will be well able to continue to serve the Ottawa area as a source of high-quality information.

Net proceeds from the sale of this book will be donated to The Ottawa Citizen Literacy Foundation, which was established in 1993 to help fund projects to promote literacy throughout the area. We thank purchasers of the book for their contribution towards promoting reading, which is so vital to the economic and cultural health of our community.

Russell Mills, Publisher
The *Ottawa Citizen*

... and now

FOREWORD

The studio is perfect, but it is not him. The light comes in through a window and over his left shoulder, but Ben Babelowsky is more interested in looking out and watching nature play with the canvas than down at his perfectly lined up brushes and clean artist's table. On the wall opposite are the reminders of a life well spent — a framed letter from the mayor, plaques from community service groups, honors from work, a special thanks from the Royal Ottawa Hospital that has gained so much through him — but he is far less interested in what has gone on before than in what will come next. He has already learned twice in 62 years that everything of material value can vanish in an instant; what lasts is art, and what matters most is the art yet to be created. Somewhere out there, beyond the perfect new homes and the controlled nature of the golf course that says Ben Babelowsky has arrived. He'd rather be gone, painting.

Lise Babelowsky finds him difficult to drive with: she cannot take her eyes off the road knowing that his are everywhere but. She sees corners and blind spots and hidden intersections where he sees the light coming off the snow in a certain manner, the sky changing color like a bruise as the sun sets, an old barn with a loose board sending shadows across the beams, a beaten home where dreams once sparked and died. He sees history moving, tide like, in and out of buildings that now sit broken, often abandoned. He sees the same possibilities in a stack of broken boards that a carpenter once saw when the boards were fresh lumber. He sees these things, and describes these things aloud, and Lise Babelowsky simply takes his word for it. She herself is too busy driving from the passenger's seat to look.

Ben Babelowsky calls this affliction his "artistic eye," and he did not understand how this peculiar eye came in so many variations until much later in life when he was already a well-known Ottawa artist. He had become obsessed with what others saw in his work,

whether they saw the same light and shadows and beauty that he had seen. He wanted to find out exactly what it was about his work that was causing people to buy it and hang it and value it. And so he had started to hang around discreetly at his own showings, not identifying himself but pretending to look so he could eavesdrop.

He had painted an old corner store — the boards so worn, the tin signs bent, the door so inviting — and two men were standing directly in front of the painting frantically whispering to each other.

"I've just *got* to have that painting," the older man of the two said.

The other man asked the very question Babelowsky wanted to ask: "Why?"

The older man pointed to the painting, his finger rising past the corner store, the signs, the main focus of the painting, and coming to rest on a half-opened window on an old house standing well into the background.

"You can't imagine," the older man whispered with a smile, "how many girls I once had in that room."

And from that moment on, Ben Babelowsky understood what it is about his paintings that affect the eyes of others: **Nostalgia.**

He was born Bernardus Babeliowsky — the "i" later vanished — on New Year's Day, 1932, in Amsterdam, Holland. His father, also Bernardus, was the third generation of a family of printers and publishers that had come to Holland from the eastern part of what is now Poland. "Printing ink," he says, "was in my blood." But it did not mix as expected.

Ben was more like his mother than his father. More energetic, more domineering, more ambitious. As the only son among five

children, he was expected to go into the family business, and there was never the slightest question that this is what would happen. Even as a child, he would spend days at the shop, usually playing with lead type — "These were the days before they knew it was bad for you."

He was then, as he remains, a dreamer whose imagination would easily run away with whatever thought happened to pass by. He remembers sitting as a very young child running his hands over a small Chinese vase his mother owned — a vase that now sits in a place of honor in his Kanata Lakes home — and thinking about where the gold came from for the plating, why the inlaid faces were scowling, who they were and what they were doing.

His first encounter with art was religious. The Babelowskys were strict Catholics and mass was a regular obligation. At home, he would draw the chalice, the cross, the holy images, always imitating, and he would not attempt anything original until he was seven years old in 1939, and war broke out following Hitler's invasion of Poland. His fascination turned from candles to bombs. He drew dog fights, planes crashing in heaps in fields, soldiers marching into cities. "War to us kids was a great adventure," he remembers, "because your parents were doing all the worrying."

But soon the adventure became no fun at all. The overwhelmed Dutch army surrendered in 1940 and the German occupation began. Still a child, Ben Babelowsky discovered — for the first of two times in his life — what it felt like to lose everything you have learned to take for granted. His family, relatively well off before the war, lost its privilege, its money. "Times were tight," he remembers. There was little food; he tasted the last of his beloved peanut butter and would not taste it again until the war was over. The Dutch currency was destroyed by inflation and bartering became an underground economy, with Amsterdam families trading everything from their bedsheets to jewellery for food. "We were very resourceful," he remembers. "We had to be."

Paper was in demand everywhere and, because the Babelowskys were printers, they had a commodity for which others wished to trade. Young Ben was sent to work the food market with paper from the shop while his older sister, Ann, rode off on her bicycle to barter for

food with farmers. At one point their father tried to come up with cigarette paper, which was in very short supply in that rice paper was available nowhere. Taking the lightest bond paper he could find, the father cut it to cigarette size and sent young Ben off to the market. The arrival of this new commodity caused great excitement until the first customer, who insisted on rolling some tobacco in it and trying it right then and there, inhaled as he raised a match and the dry, highly-flammable paper exploded into a flame that shot straight up his nose.

They lost more than standing and currency. They lost friends and neighbors as the Nazis rounded up Amsterdam Jews and sent them off to camps. In the apartment building in which the Babelowskys lived, the neighbors above and beside were Jewish, and young Ben, barely 10, remembers many of them being hauled away — "and they never came back." One of their Jewish neighbors, who had fled before the Germans entered the city, later returned with the liberation forces, carrying in his pack a jar of peanut butter for the little Babelowsky boy upstairs. The soldier was the only one of the family he ever saw again.

Toward the end of the war, his father began publishing and distributing an illegal newspaper, even though by then Germans were occupying the Salvation Army headquarters next door to the printing plant. With no power available, the elder Babelowsky configured a simple press that could be run from a flywheel powered by someone — often young Ben — pedalling furiously on a bicycle. They collected and printed news from the radio and from word-of-mouth. "It was amateurish," he remembers. "Half of it was stencilled, half typewritten. People made fun of it — but they wanted it."

The war ended and the printing plant went back into operation and Ben Babelowsky returned to his painting. He began working with the Dutch landscape, low ground, high sky, and he began selling these works to uncles, aunts and friends of the family. He was certain he had found his calling: "That really turned me on to art — when I had some extra money in my pocket."

But still there was the expectation that he would be going into the family business with his father and two uncles. It was arranged that, at the end of high school, he would undertake a management

course and enrolled in the Amsterdam School of Graphic Art. Here he studied every facet of printing and publishing, constantly dreading the thought of graduating and going to work for the family business. "I didn't want to have any part in it," he says. "I had the education and my papers, but I didn't want to do it. I wanted to do my own art."

He hated the management part, but fell in love with the craft side of his studies. "The beauty of the school," he remembers, "was that they insisted you learn all the old ways of printing. How to do etchings. How to do engravings, prints. It was the creative end of the business, and I was really turned on by that."

At the art school he met another student, Lise Dekker, from the eastern Dutch town of Nymegen. Unlike Babelowsky, she came from a long line of Dutch painters, the Maris brothers who were all, at one time, members of the renowned "Hague School of Art" of the late 1800s. Her great-grandfather, Jacob Maris, had been the best-known of all. She remembers vividly the first time she saw Ben Babelowsky, her attention captured not by his six-foot-plus or angular features, but by the sound of his name as it was called in the dentist's office in which they both happened to be waiting. "'**Babelowsky**,'" she kept repeating to herself. "Such an unusual name." They soon met at a dance, and within a matter of months she had agreed to take on the name herself, neither of them aware that, years later, the unusual ring of that name would be of enormous value to an artist trying to gain recognition. "If my name was Jones," Babelowsky could laugh in 1994, "I wouldn't get half the recognition I get."

In 1952, he began his compulsory two-year stint in the Dutch army, but by then he and Lise were already planning a new life in another country. "Lise comes from a very adventurous family," Babelowsky says. "My family was not. They were very conservative. But Lise's family always had maps spread all over the floor planning where they would go and what they would do." They discussed any number of possibilities — Australia, New Zealand, United States, South Africa, Brazil — but settled on Canada because, like all Dutch at the end of the war, they had developed a great fondness for the big, unknown country north of America. "We had Canadian

soldiers in the house during the Liberation," says Lise Babelowsky. "That's why we came here."

In September of 1953, Lise and her parents left for Canada, headed for Toronto. It took her fiancé several months to arrange his way out of the army, but in November he was able to join them. And together they hated it. "Toronto was so backward in the 50s," remembers Babelowsky. Lise Babelowsky remembers "Once at a restaurant I asked for a glass of wine with my meal — and they asked me if I was a 'wino' or something."

But what Toronto the Good did have was work. "I arrived on Sunday," remembers Babelowsky, "on Monday I had a job." The irony was that the job was in precisely what he had left Holland to escape: commercial printing. "It was a sweatshop," he says. "But since it was non-union, they let me fill in anywhere. I was able to learn all kinds of jobs."

They stayed five years in the city, living in North York. Their first child, a son, Jeffrey, was born there in 1958. Like most Torontonians, they turned north for escape, falling in love with Muskoka and Haliburton and eventually buying a cottage in Haliburton, where Babelowsky's painting entered yet another phase: pink rocks, blue lakes and fall colors. He sold some, but commercially he could not crack the haughty Toronto market. As the dealer at the Eaton's College Street gallery told him, "People don't like water color because they can't *feel* it." He admired Babelowsky's work, but only if it could be mass produced and mass marketed. "How many of these," he asked, "do you think you could do a day?" Babelowsky turned and walked out.

He kept painting the north and the young couple kept exploring further and further away from Toronto. When they began hearing about the uranium boomtown going up on the edge of Elliot Lake in Northern Ontario, they joined the rush in 1958 and left Toronto for good. They arrived before the streets were paved and soon there were 31,000 people living in Elliot Lake and working the 11 uranium mines. Babelowsky found work at the *Elliot Lake Standard* where he did everything from layout to political cartoons to, at one point, even writing a column. Times were good. They built a new home. Bought a car. New appliances. And then, in the

snap of a finger, times were no longer good at all. The uranium market collapsed, and Elliot Lake became a ghost town overnight.

For the second time, Ben Babelowsky understood what it is to lose everything. "We were so naive," he says. "So naive." Sears came and took back the appliances. He had to fork over the house keys to the mortgage holder. Lise and Jeffrey set out to return to her parents in Scarborough until Ben could find work and send for them. He sold his remaining paintings for enough money to go to the Hudson's Bay Store and there he purchased a red coat for Lise so she would have something for the advancing winter. This red coat — sometimes a dress in summer paintings — would become his secret signature, found in most of his work and often buried in background. But it is there for a reason. So they never forget how easy it is to lose everything. "She knows why I do it," he says.

Babelowsky ended up in Iron Bridge outside of Sault Ste. Marie. A trapper, Mel Lessard, took him in and let him pay rent with paintings, but Babelowsky spent far more time trapping and skinning and learning to live in the bush than he did painting. "They were tough, tough times," he remembers. "But I never got down on Canada. I would never admit defeat." He couldn't even tell his parents back in Amsterdam what had happened to them. "There's no tradition of a ghost town in Europe. They wouldn't know what it was. They wouldn't have understood. I just told them we were moving."

Looking back, both now treasure this disaster and what it did for them. Babelowsky ended up with an education in living in the bush, and he learned for the second and last time that possessions are not important. "I saw it as an adventure," says Lise Babelowsky. "It was teaching us about other people. We were spoiled. I thought that Ben had a good job, nothing could touch us. Then I found out how everything works."

Ben Babelowsky learned that the work on the side that he had been doing all his life was more important than he had first realized. "I'm the original moonlighter," he says. He did oil paintings of industrial scenes, mines, steel mills — all of them commissions. He painted the signs for a golf driving range — "200 yards," by Ben Babelowsky. He decorated the inside of a driving instruction school, painting stop signs and yield signs on the walls. "I painted

the walls of the beverage room of the Algoden Hotel, a huge map of the area with all the lakes in it and all the sorts of fish and wildlife that were found around there. Drunks used to sit there pointing at the wall and arguing about what they'd caught in what lakes."

But then a real job broke: the *Sault Star* was hiring and he got on. Lise and Jeffrey came back north, they moved into a house and, in 1961, their daughter Jennifer was born. But four weeks after the birth, they were gone. Babelowsky had liked the 'Soo' but disliked the *Star* where he felt "overworked and underpaid." He went to Sudbury for a while and to work for the *Star* — "the first, and *last* time, I worked for a Thomson paper."

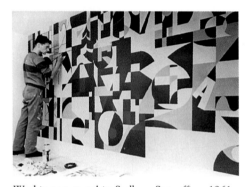

Working on mural in *Sudbury Star* office, 1961

It was in Sudbury where Babelowsky first became involved with fund raising. A group wanted to establish a university in the mining town and they turned to a professional fundraiser who hired Babelowsky to work on brochures. They would take a big name — even, at one point, billionaire John Paul Getty — and Babelowsky would do a mock-up of the proposed university buildings with the targeted donor's name all over them: John Paul Getty Library, John Paul Getty Science and Humanities Building, John Paul Getty Athletic Complex... Getty never did get involved, but "It worked — Laurentian University is there, isn't it?"

Still, Sudbury was not to their taste. "When visitors came," they remember, "the highlight was to take them out to see the slag heaps." It was not the people — they loved the outgoing, friendly northern character and found the contrast striking to cold, conservative Toronto. But they missed the restaurants and theatre and art galleries of a vibrant city. There was little desire to return to Toronto, but an ever-growing wish to get to a Canadian city where they would feel they belonged.

After two years, Babelowsky had had enough. "I finally said to Lise, I can't take it any more." He sat down and wrote letters to five newspapers picked at random: the *Vancouver Sun, Calgary Herald, London Free Press, Globe and Mail* and *Ottawa Citizen.* All five papers replied, but only the *Free Press* and the *Citizen* had immediate openings. In 1963 he took the train down to Ottawa where advertising manager Jim Hillock and advertising director Len Gates met him at Union Station and walked him over to the Chateau Laurier for a long, extravagant lunch. By the end, the future was no longer under discussion.

"I fell in love with the paper and the city."

It has been a mutual affair. If Ottawa has been good to the Babelowskys, they, in turn, have been good to this city. He began a highly successful, 30-year career at the paper, moving from the advertising department to director of promotions and community relations, from which he retired at the end of 1993. Through all that time he continued to paint and, of course, moonlight — everything from commissioned scenes to the Giant Tiger logo — but he found his great popular success in water colors of the Eastern Ontario and Western Quebec landscape. The wood barns, the difficult fields, the rivers, the easy rolling hills, the churches, the slow burning summers and the fast freeze that is Ottawa winter. And it was here that others found Ben Babelowsky.

He has a sense of his own art, not only what it does to others but how it is seen by others. He knows that, in the world of conflicting art philosophy, his work can be dismissed as quickly as others might embrace it. What is nostalgia to one older man might be cloying sentimentality to someone else. But he knows, too, from hundreds of letters and casual conversations and more invitations to talk to art classes than he can take on, that the admirers far outnumber the detractors.

He remembers once being accused of producing "saleable art" by an artist more into abstract work. "I don't mind," he says. "That's a measure of success." In fact, Babelowsky is himself very fond of abstract art, and the collection of wood carvings, paintings and sculpture that grace the Babelowsky home could only be described as "eclectic." In Babelowsky's opinion, "There's a place

for everything — even that piece of metal rusting in a park. Sure, I worry like anyone else about some things being bought — but I also believe there's a place for everything."

If he has a role as an artist, he says, it is that, "I preserve heritage. A lot of the things I paint are gone. Or are going. Or are in danger of going." If he could work only to please himself, he would concentrate on quick, spontaneous sketches done on location, much as Tom Thomson and the Group of Seven worked earlier in the century. "You have to work fast," he says. "You do your best work then. You don't agonize. You don't labor over it. The spontaneous work is what I enjoy the most." But this is not the art for which he has become known. When people talk of Babelowsky art, it is of pen and ink sketching and watercolor, realism. "People expect detail," he says. "They want to be able to recognize their place."

He discovered this the hard way more than a decade ago when his then agent, Colleen Fogarty, obtained for him what appeared to be a sweet commission: three watercolors of Quebec scenes to be made into 225 prints for a new hotel being built by the Campeau Corporation. They made the mistake of agreeing to deliver the prints fully framed, and the result of that promise — weeks spent in the Fogarty basement cutting glass and assembling with Colleen Fogarty, her husband, Ken (a former mayor of Ottawa) and their two sons — gave him a life-long dislike for framing. Yet the framing was not the worst memory of this commission.

One of the three scenes he had selected to paint was of the old Wakefield covered bridge, and Babelowsky — a determined realist — had even put in the yellow-and-black height restrictions sign over the entrance. The hotel architect, however, decided this detracted from the bucolic sense of the scene and demanded the offensive sign be removed. With the architect refusing to budge, Babelowsky elected to repaint the scene, minus the sign.

Several years later, when his mother was visiting from Holland, Babelowsky took her to the hotel so she could see that he was not only a painter, but a painter so successful his works were hanging in one of the city's finest hotels. Babelowsky fetched a hotel worker to show them one of the rooms, and it turned out to be a room where one of the Wakefield bridge prints graced the wall. Unwittingly, the

hotel employee took great pride in pointing out the painting and recounting a well-told tale that the hotel owner, Mr. Campeau, had had a terrible fight with the artist over some hideous addition that the artist had put into the landscape. The artist had refused to remove the offending addition and Mr. Campeau had been forced to order it expunged. The artist, the hotel worker added, was obviously "crazy." The Babelowskys quickly left — without ever identifying themselves.

There were other times when he might well have wished his execution of a scene were not so precise. Setting out not so long ago to paint a reader's suggestion that the Luskville Falls be included in his popular *Sunday Citizen* "Locales" feature, Babelowsky came across "this Mickey Mouse creek I thought was the falls." He painted it, the paper ran the scene with the title, "The Luskville Falls" and the phones began ringing the moment the paper hit the street. His future plans now include painting the *real* Luskville Falls — if he can find it — and the "Mickey Mouse creek" now hangs in a place of honor in Babelowsky's home, a magnificent joke better told on himself than by others.

The hugely popular "Locales" series would never have come about had Babelowsky not accidentally stumbled on what would become his artistic life's calling. In 1981, he was painting down by the Bytown Museum where the Rideau Canal empties into the Ottawa River, and he was working on a scene looking back toward the locks and the Chateau. "I kept thinking," he remembers, "there are more than 40 locks between me and Kingston, and I've only seen a few of them. How can I get to see them all — and get the *Citizen* to pay for it?"

The solution was to come up with a project the paper would go for, and since the canal was about to celebrate its 150th anniversary in 1982, the opportunity was obvious. The paper liked the suggestion and agreed to send a houseboat the length of the Rideau Canal carrying Babelowsky along with *Citizen* writer Tom Van Dusen and photographer Lynn Ball. Van Dusen and Ball would supply stories each day of the progress from Kingston, and Babelowsky would paint watercolors of various locks. His idea was to do an even dozen and then publish them as a calendar. Russ Mills, then the editor of

the paper, had a better idea: do eight prints, and the paper would then sell them as $12 sets. They selected a needy, underfunded charity — the psychologically disabled of Eastern Ontario — and hoped to raise a few thousand dollars, with luck. The money would go to such deserving operations as the Royal Ottawa Hospital.

It was a great trip, the best story of which never appeared in print or as a print. One of Babelowsky's tasks each morning was to call in to radio station CFRA where the morning man, Ken Grant, would interview him about the previous day's journey and talk about the day to come. In the glorious days before cellular phones, the threesome would have to locate a pay phone after docking each night, and the radio ritual was subject to great ridicule by writer Van Dusen and photographer Ball, who would listen in each morning on the boat's portable radio and then razz Babelowsky when he raced to board the departing houseboat. Near the end of the trip, at the Long Island Lock in Manotick, the phone booth was in sight of the boat, and Babelowsky rose early and headed over for his morning call.

"How are your buddies doing?" Grant asked when they went live to air.

Babelowsky naturally looked back toward the houseboat — where his shipmates were mooning him from the windows.

"Well," Babelowsky said, "all I can say is they're smiling at me right now."

It was only when they arrived back in Ottawa that the realization settled in on them that the Rideau trip had been such a huge success. Crowds began meeting them at the final locks, waving to them from the bridges. At the final lock at the

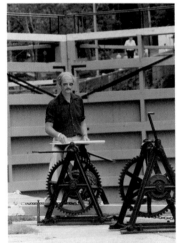

Working on canal prints, 1982.

Chateau Laurier, Colonel By himself was there in full costume, and the CBC was broadcasting live. Babelowsky's paintings were

completed and they talked about a print run — he thought maybe 2,000 and the paper went for 5,000, more on account of the low unit cost than raised expectations. Four times they had to return to the printers, finally printing 24,000 sets and raising $180,000. The sets now sell, when available, for up to $250.

The Canal Series was such an astounding fundraising success that Babelowsky and the *Citizen* eventually began looking for another, similar project. A reader had written in to suggest a series of prints on the Tall Ships, which were scheduled to visit Canada in 1985 as part of the celebrations tied to the 300th anniversary of the founding of Quebec City. It seemed a fine suggestion, and Babelowsky selected four ships that were coming and painted them with various Canadian backdrops. For the British ship, *Marques*, he chose the skyline of Toronto, but the scene never took place, the *Marques* having gone down off Bermuda when struck by a freak hurricane while racing toward Halifax, with the loss of 19 lives. One of the other papers selling the set wanted to drop the print from the set, but in the end it was decided that the scene would remain. In an eerie way, it made the paintings especially unique. And the readers loved them. The Tall Ships series sold 36,000 sets and raised some $240,000 for charity.

In 1987, *Citizen* writer Daniel Drolet travelled the length of the Ottawa River and wrote features on the waterway that ran with Babelowsky paintings of various sites along the river. The *Citizen* produced a third set of prints — six in a set, 16,000 sets in total — that, this time, raised $180,000 for the psychologically disabled. By 1994, with more than 600 paintings to his credit since he arrived in Ottawa and with other fundraising ventures involving area churches and causes, he could say that he had made a million dollars as a painter — and given it all away. He has also been credited by a number of small business owners with personally saving their framing business with the various prints. He once calculated that, at a conservative $40 a print for framing, the charity sets added up to a potential $28 million in business for area framers if every print ended up on a wall.

Babelowsky is fully aware that he has benefitted as much as anyone from the success of the series of prints and the popular

continuing series, "Locales." The more the prints spread, the more his name gained recognition beyond the oddity that first attracted Lise Dekker in that Amsterdam dentist's office more than 40 years ago. The widespread popular recognition brought him commissions, and the paintings he was able to do apart from the various series have been in demand. In the fall of 1994, Ben Babelowsky had his seventh one-man art show since moving here in 1963 — one, in 1988, was hosted by the Dutch ambassador at the Dutch Embassy in honor of Babelowsky's 25th year in Canada.

But still, it is the prints that he is most proud of — proud of what they became and what they were able to do for those who needed help, proud even that, a few years back while visiting Germany, his father-in-law was able to swap a set of them for some emergency dental work. The Rideau Canal prints are on walls all over the world, taken back by tourists and sent by relatives, embassies, convention planners. A Babelowsky print of the Peace Tower will be given by the Government of Canada to dignitaries visiting Parliament.

He likes to think that, in his own way, he has brought others' attention to Ottawa, that he may have played some small role in getting people to notice what we too often take for granted.

As he says, "If you live in a place that nobody paints, you feel it's not worthy."

Roy McGregor

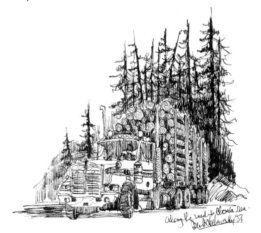

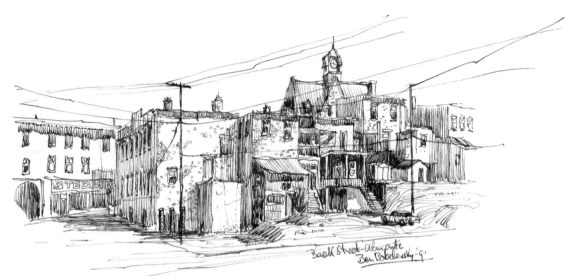

Booth Street-Almonte
Ben Babelowsky '91

"LOCALES": AN OTTAWA VALLEY PORTRAIT

◆ ◆ ◆

*Every weekend, in the **Sunday Citizen**, one of my paintings is featured on
the popular "Sunday Best" page. There is something very gratifying
about receiving all those requests from **Citizen** readers from all over the Valley.
And they're all into nostalgia — scenes from their town, village or neighborhood.
They ask for their post office, their town hall, their corner store or —
and this is their most frequent request — their church.*

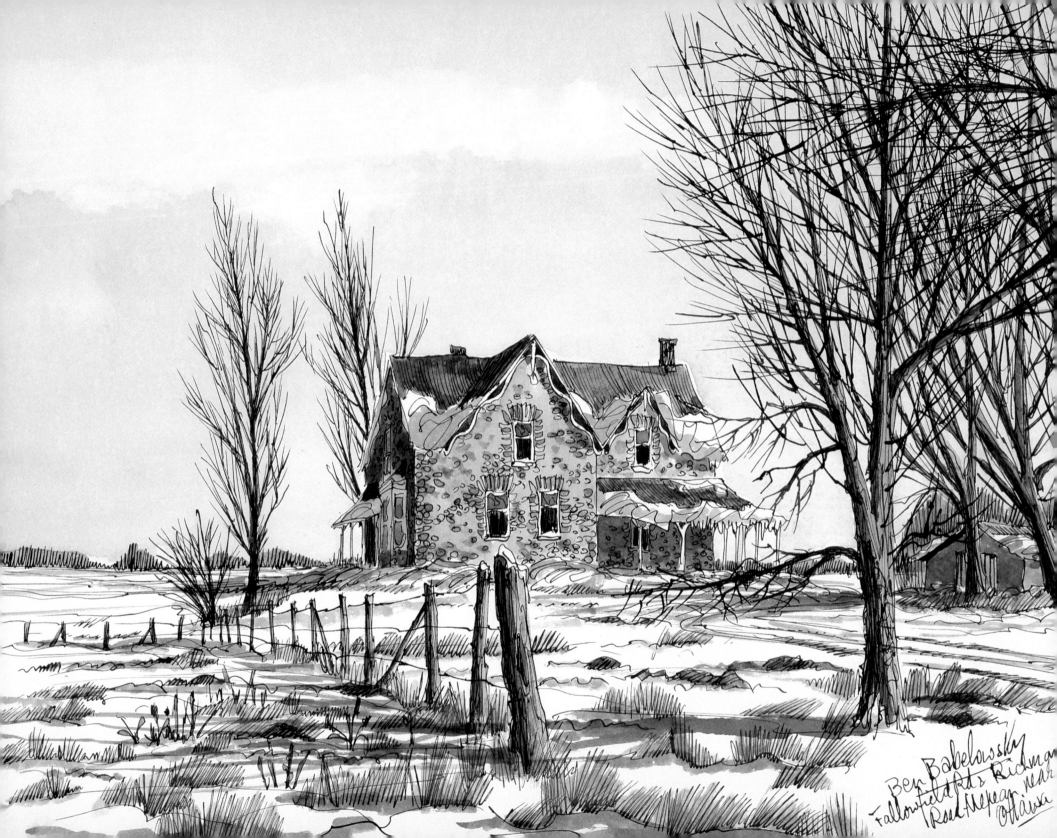

Ben Babelowsky
Fallowfield Rd & Richmond
Road Nepean, near
Ottawa

Bridge at Blakeney

The Mississippi River rushes under this narrow bridge between Almonte and Pakenham into picturesque rapids downstream.

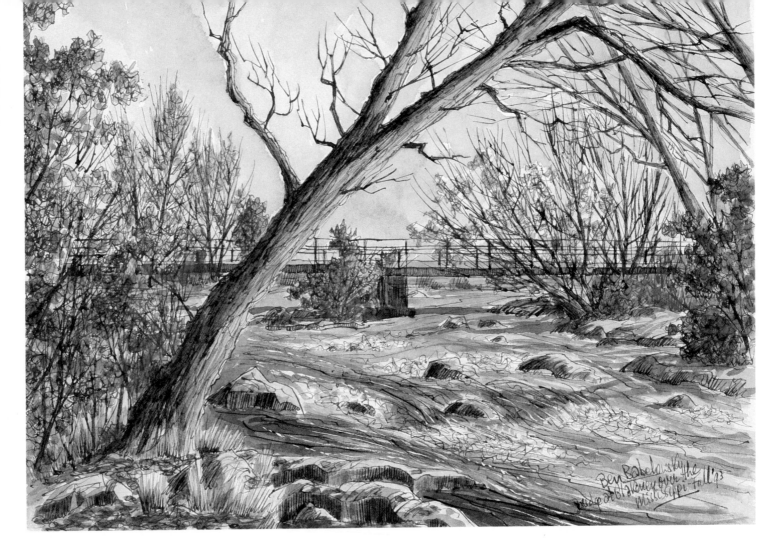

Edward Monaghan House

Ten children once lived in this old farm house at the corner of Fallowfield and Richmond roads. Built in 1866 by Edward Monaghan, the son of an Irish settler, it remained home to the large Monaghan family until 1971.

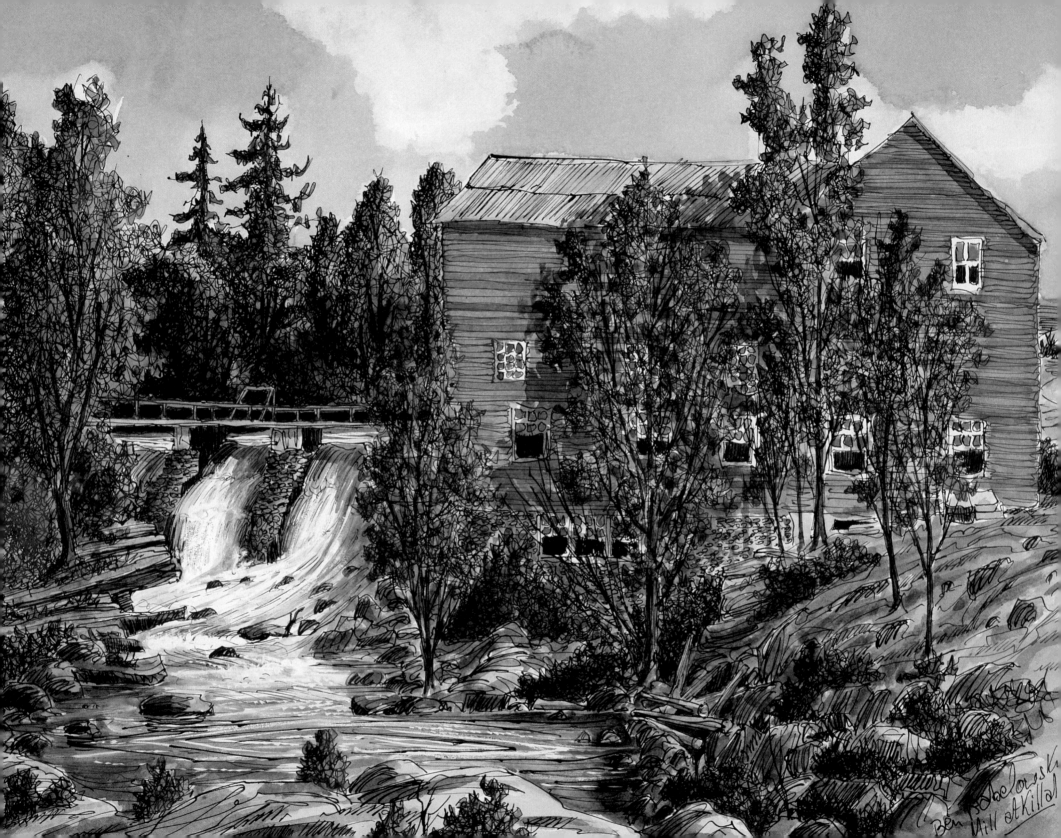

Ben Babcdoroski
Mill at Killa

M&R Feed Mill, Quyon

Originally powered by the Quyon River, this flour mill was built in the 1880s. About half of the original building still stands but was expanded for today's production of livestock feeds, bird seed and fertilizers in this west Quebec town.

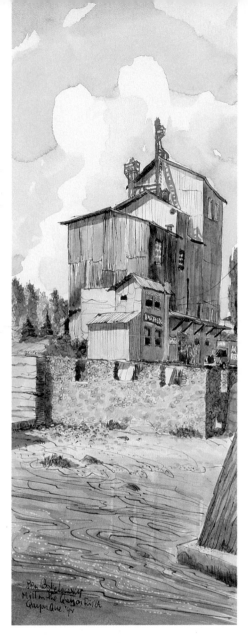

Maclaren Grist Mill, Wakefield

The mill William Fairbairn built in 1838 was operational until the early 1980s. It took its name from James and John Maclaren, who bought the mill in 1844 and added a woolen mill and lumberyard.

Courtesy Mr. and Mrs. John Geleta, Sr.

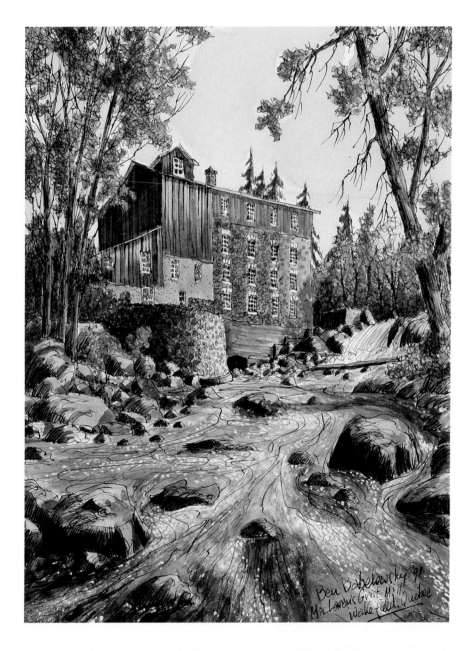

Mill at Killaloe

Rising hydro costs don't bother Andreas and Petra Vornweg, owners of this historic mill in old Killaloe. In 1992, after restoring the adjacent dam, they started generating electricity to sell to Ontario Hydro, producing enough to service 10 to 15 homes.

15

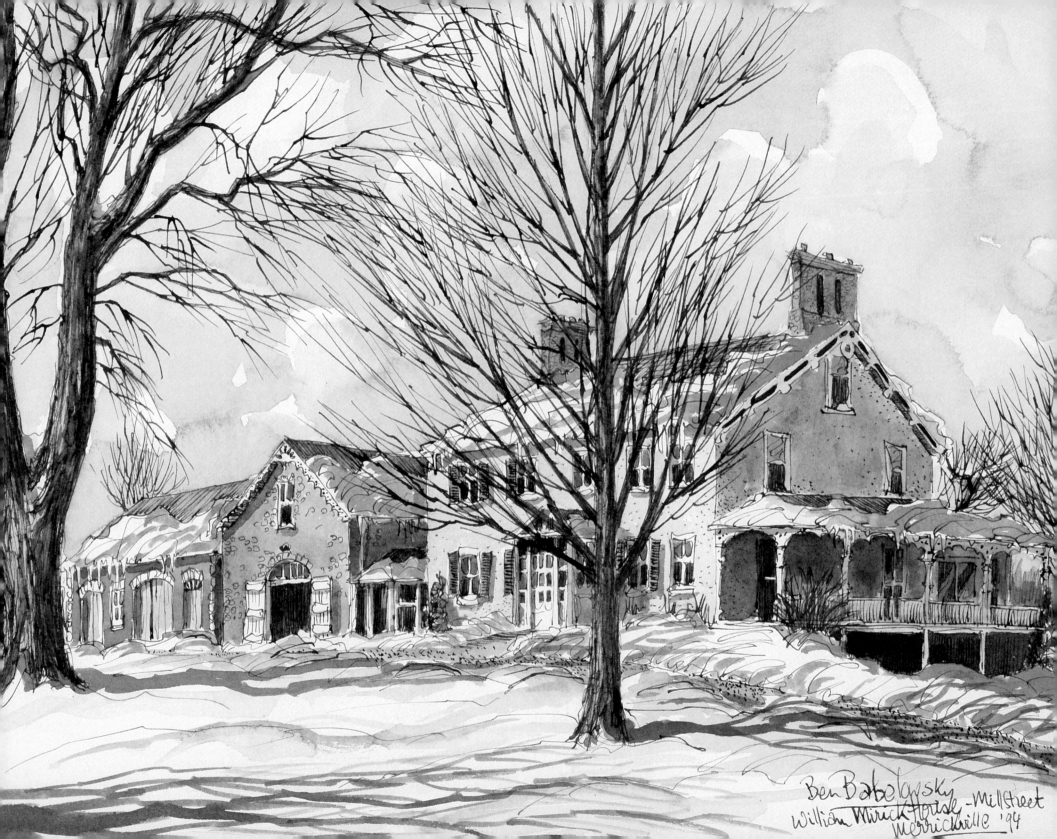

Ben Babelowsky
William Merrick House - Mill Street
Merrickville '94

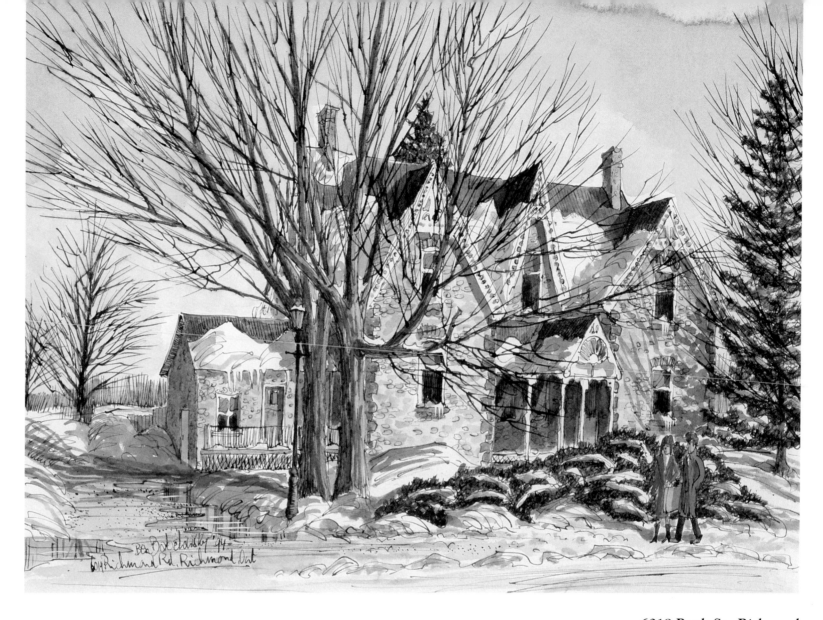

6019 Perth St., Richmond

James Stewart was determined not to lose another home to fire when he built this house in 1895. It was the local undertaker's second house — the first was gutted by fire. The maple trees on the front yard still carry the scars from the heat of the blaze.

William Mirick House, Merrickville

This Georgian-style house near the Rideau River in Merrickville was the third and final home of William Mirick, the industrial magnate who founded the village in the 1790s. Mirick built the Mill Street house in 1821 and lived there with his family until he died in 1844.

Courtesy Mr. and Mrs. Glenn Vodden

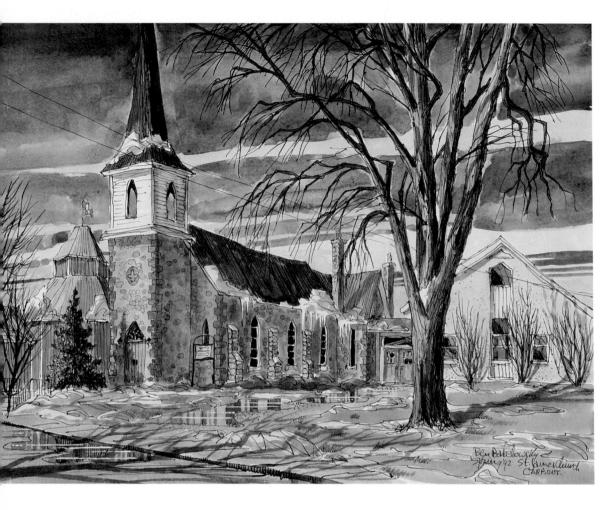

St. James Anglican Church, Carp

In the heart of the small village of Carp sits the youngest of three Anglican churches in Huntley Parish. St. James Anglican Church was built in 1898 after the construction of the railway brought new settlers to the town.

Courtesy Mr. Brian Hickman

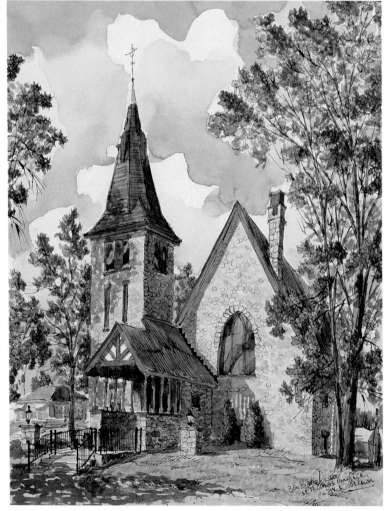

St. Thomas Anglican Church, Woodlawn

Built in 1915, this country stone church in West Carleton is a blend of neo-Gothic and Tudor styles. Many of its original features, including the stained-glass windows, are still intact.

St. Brendan's Church, Rockport

Up until five years ago, Sunday mass at this 102-year-old church between Brockville and Gananoque was held outside on the rocks overlooking the St. Lawrence Seaway. The stark white church, which was named after the Celtic saint and noted navigator, stands out boldly against the pink rocks of this scenic point.

Courtesy Mr. and Mrs. Fred Dekker

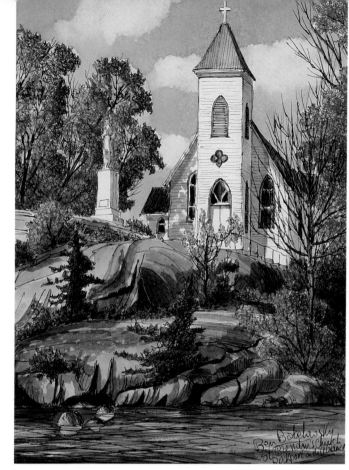

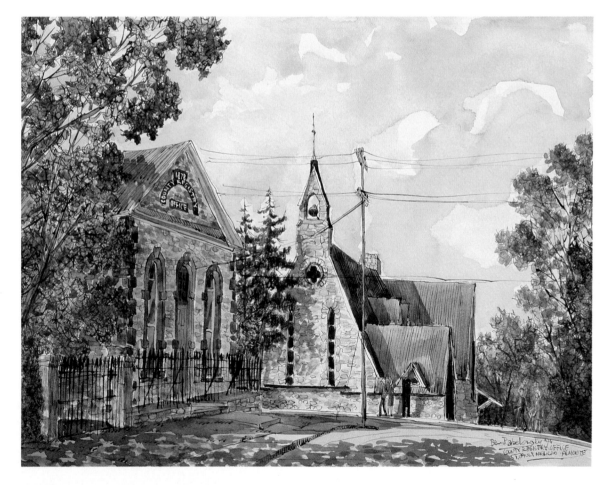

St. Paul's Anglican Church, Almonte

This beautiful stone church at 70 Clyde was built in 1863 by local builder James Scott for $3,740. Today, the traditional English-style parish has retained most of its original features, including the small bell tower and pine pews. Across the street is the former county registry office.

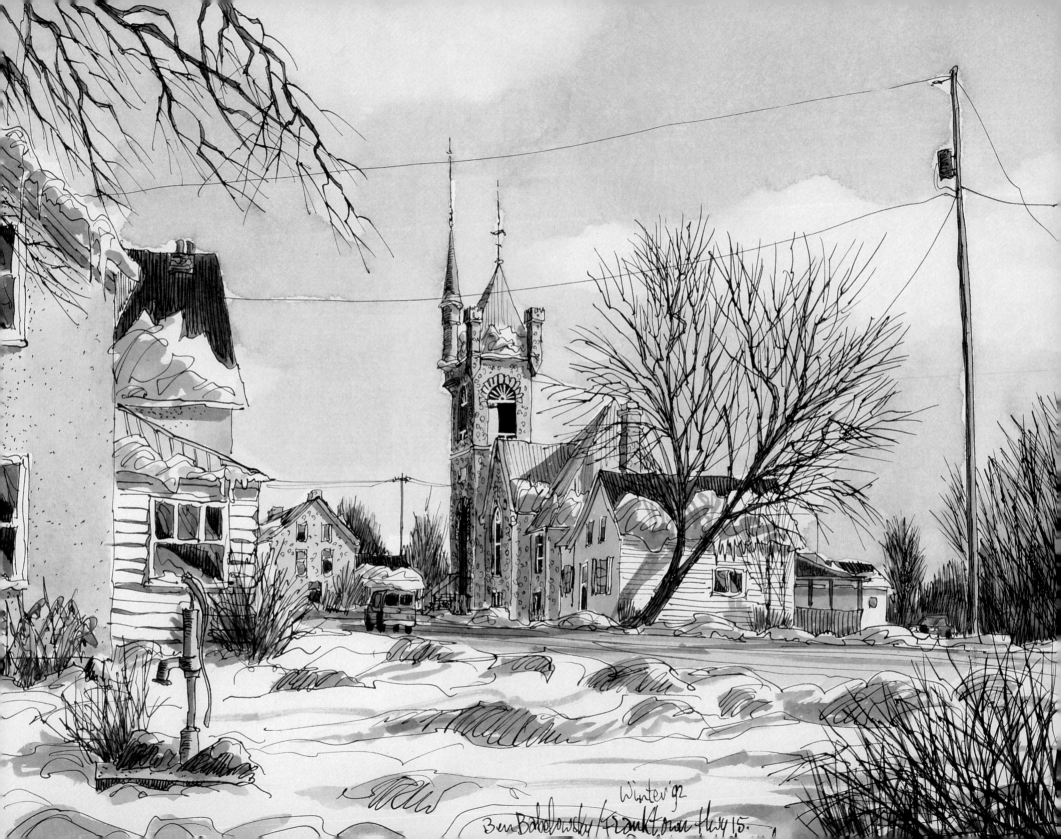

Winter '92

Ben Babelowsky/Franktown Hwy 15.

St. Mary's Anglican Church, Navan

If it wasn't for the generosity of local volunteers, this stone church south of Orléans might never have been built. Residents of the small village gave their time and energy to help build the parish in 1898.

Courtesy Mr. and Mrs. Peter Clark

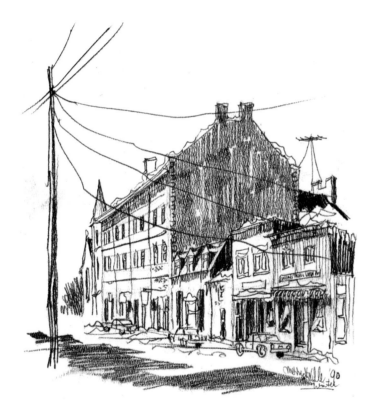

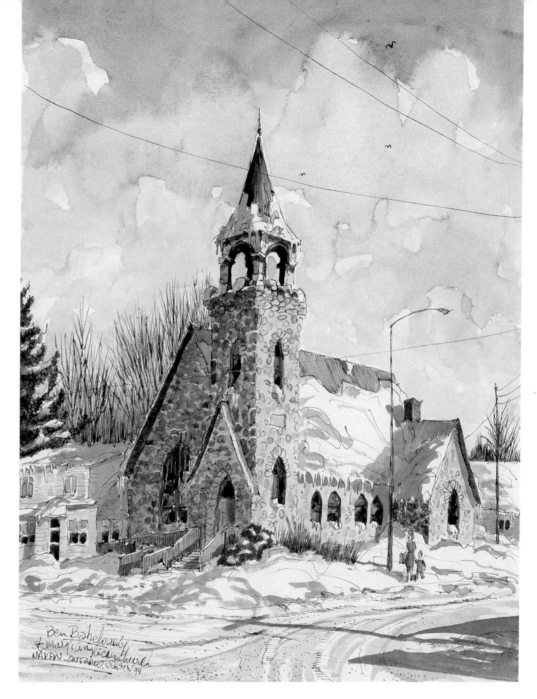

St. Paul's United Church, Franktown

Originally built for a Presbyterian congregation, this 90-year-old church in the hamlet of Franktown became United in 1925 following church unification with the Methodists. The church was constructed from fieldstone from a nearby quarry. Much of its interior is original.

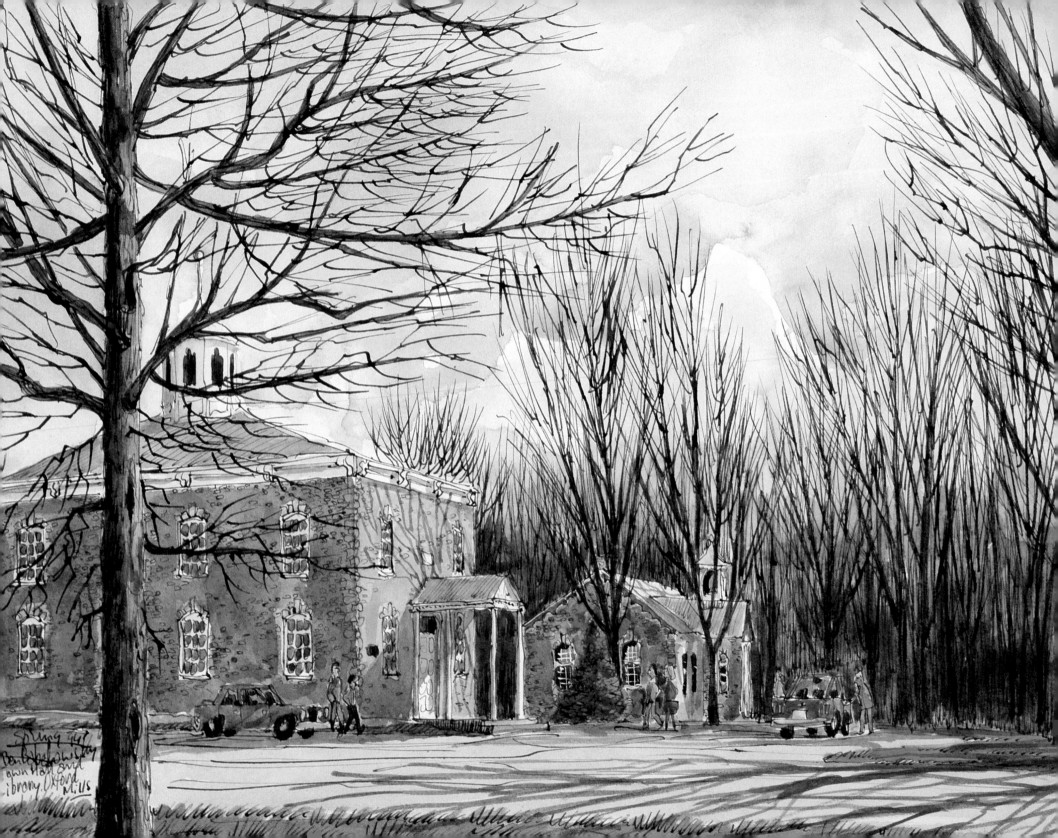

Spring 94
Danforth Chapel
Town Hall and
Library Oxford
N.H.S.

Towers Island, Gananoque

Originally built in the early 1880s by a Cobourg doctor, this summer home sits on Towers Island and overlooks the Wanderer's Channel, about two kilometres south of Gananoque on the St. Lawrence River.

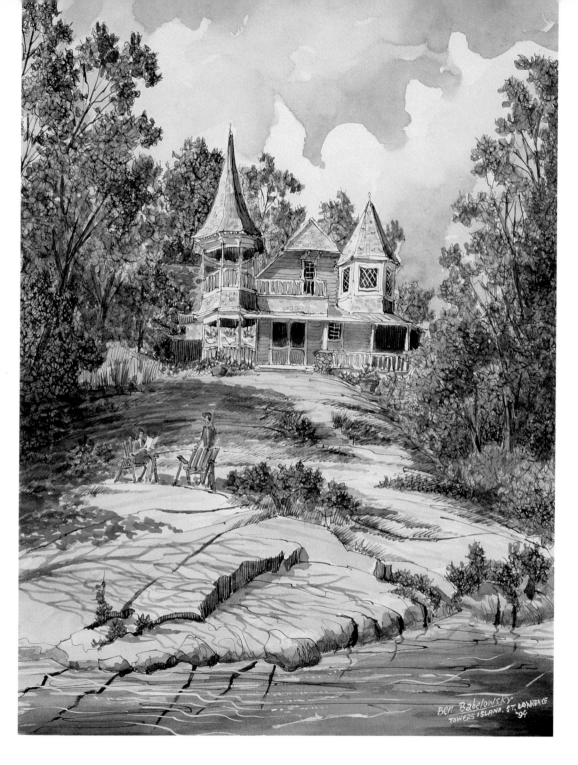

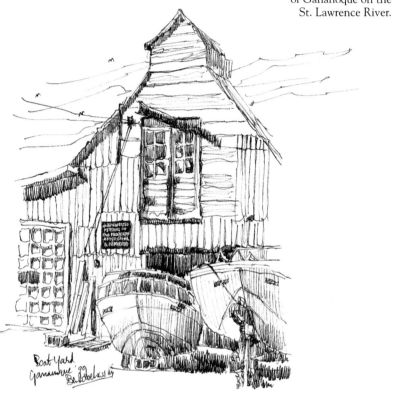

Township Hall and Library, Oxford Mills

The township hall in Oxford Mills was built in 1875 of stone from the Harris quarry. At the time, council met at the back, which is now the municipal office. The two-room building next door was also built in 1875 with Harris quarry stone.

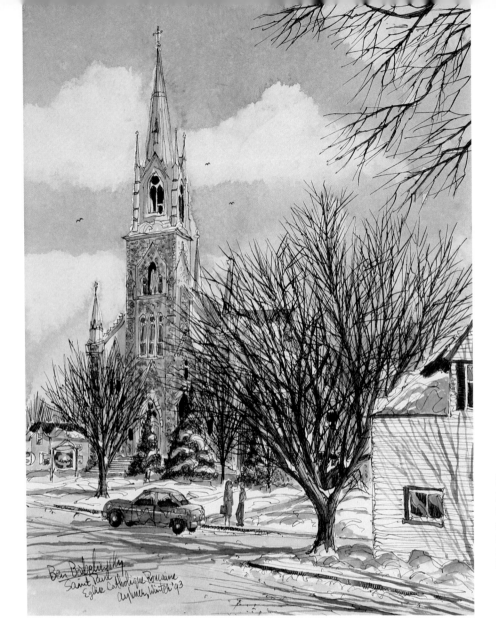

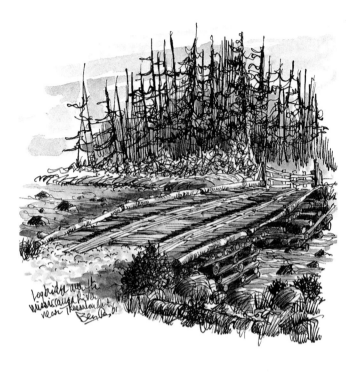

St. Paul's Church, Aylmer
It's been 153 years since the first Catholic church was built here at the corner of Eardley and Notre Dame in the centre of Aylmer. Two fires and three churches later, this stone building was constructed in 1905.

Military memories
The Stockade Barracks and Hospital Museum at 356 East St. in Prescott is Ontario's oldest surviving military building. This Georgian stone building was built in 1810 by Major Edward Jessup, Prescott's Loyalist founder. In the War of 1812, it was used as a British soldiers' barracks until 1815 when it served as a military hospital.

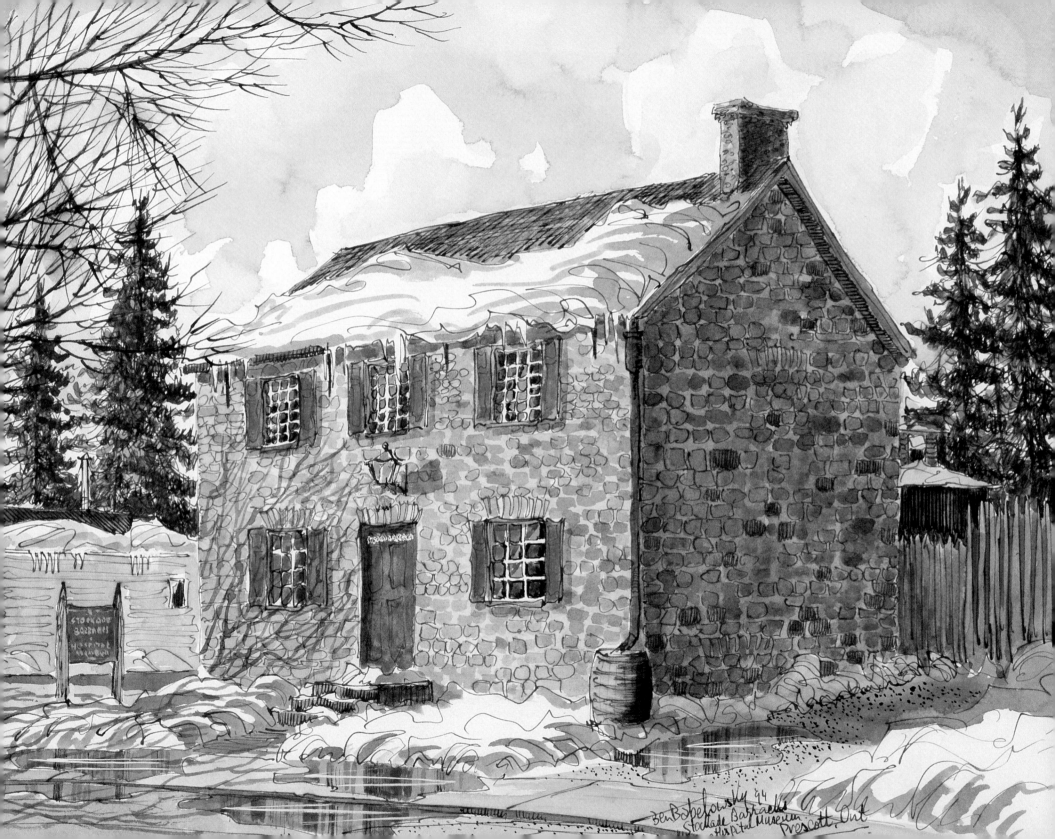

Ben Babelowsky '94
Stockade Barracks
& Hospital Museum
Prescott, Ont.

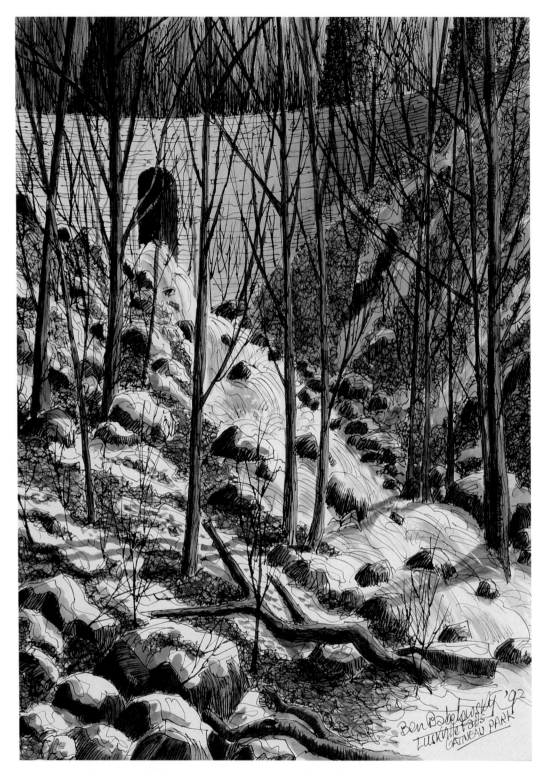

Gatineau Park Creek

Mistaken by the artist for Luskville Falls, he painted this scene in response to a reader's request for the well-known scenic falls in the Quebec town of Luskville.

Mount St. Patrick's Church, Renfrew

From the inside, this Tudor Gothic parish looks more like a cathedral than a small country church. Originally made of wood, the church was built in 1843, when Irish Catholics settled in the area.

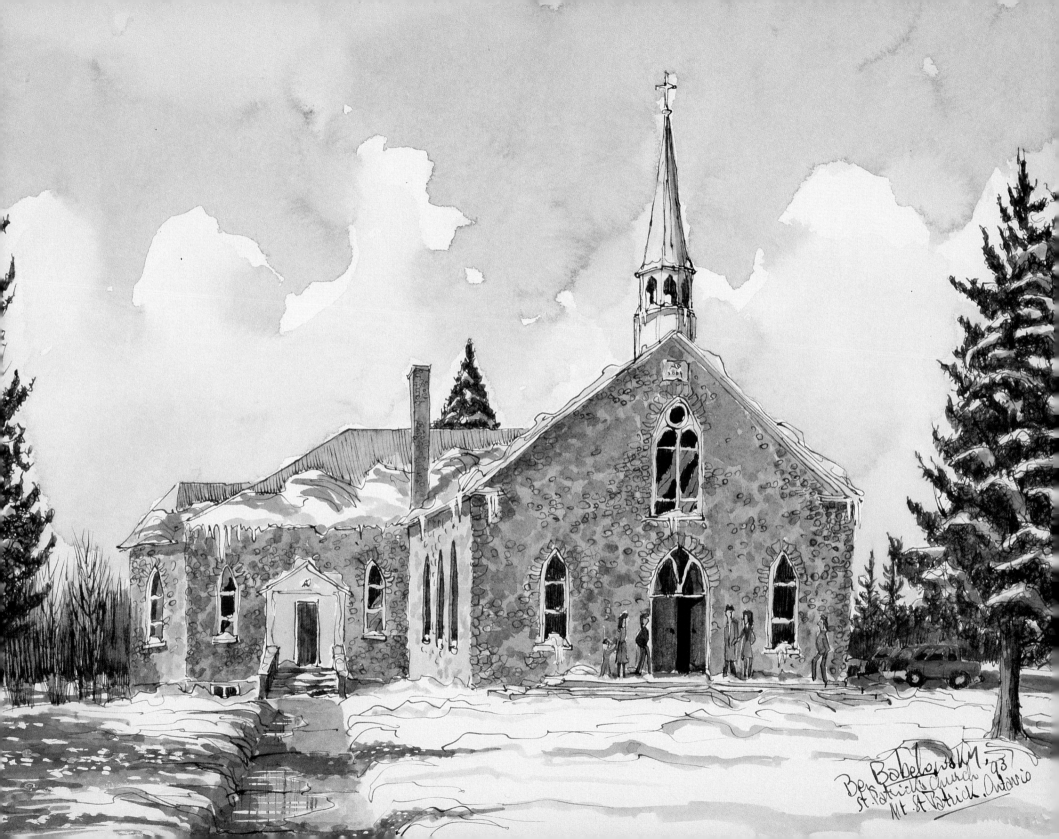

Ber Babelowski '93
St. Patrick's Church
Mt. St. Patrick, Ontario

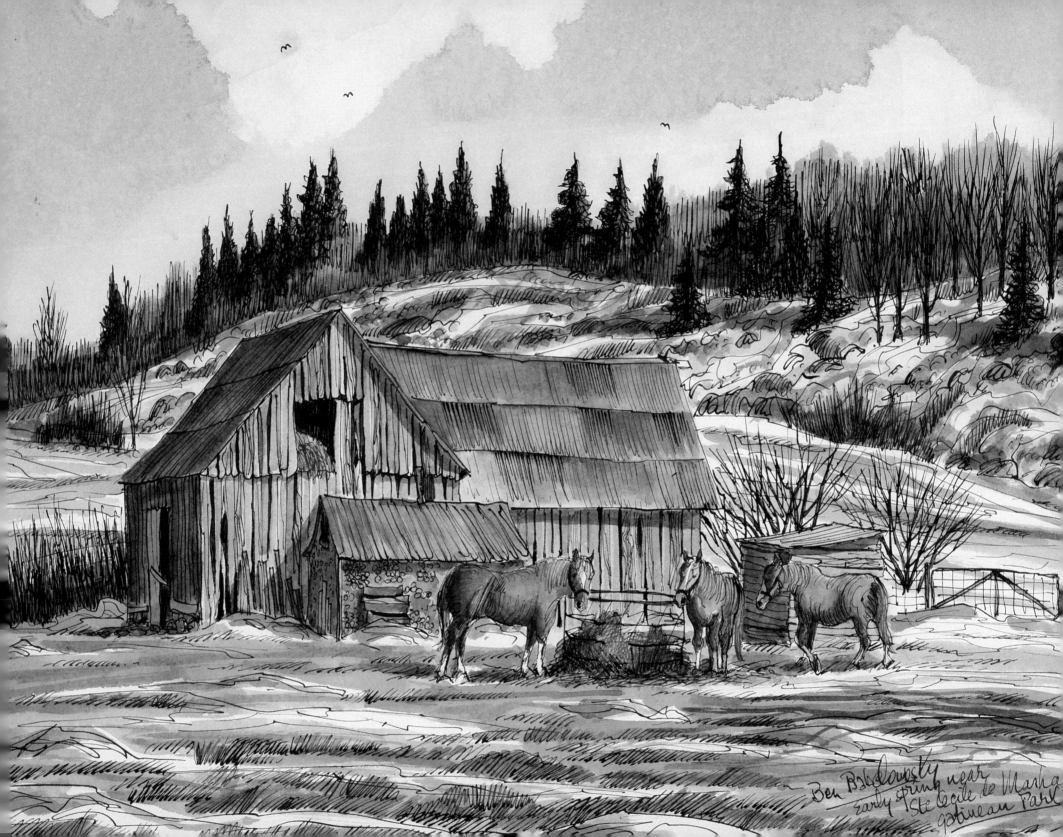

Ben Babarovsky
Early spring near
Ste Cecile de Marha
Gatineau Park

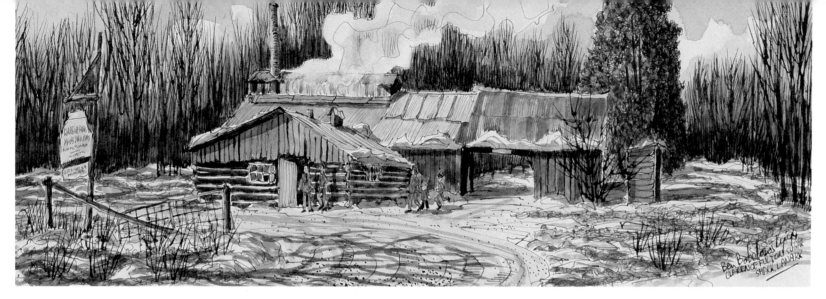

Maple Syrup Time
Every spring the sap runs at sugar bushes throughout the area, such as this one on Clarence Fulton's farm near Pakenham.

King Street, Brockville
Small shops and restaurants in century-old buildings line the main street of this picturesque city of about 21,000 people 90 kilometres south of Ottawa.

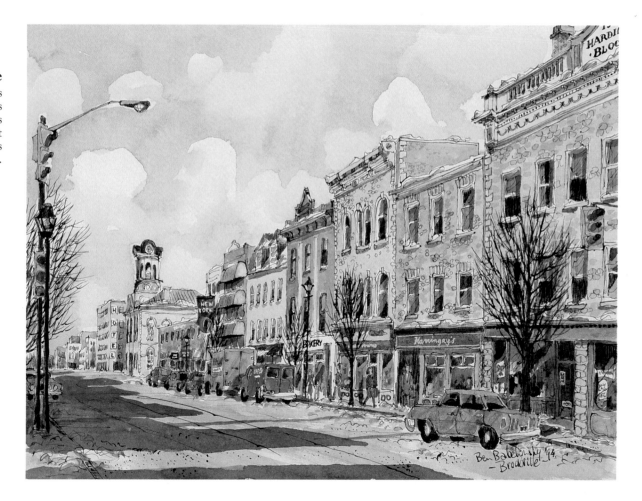

Farmland near Ste. Cécile De Masham
Horses graze on this farm near Ste. Cécile de Masham on the edge of Gatineau Park. This area to the north of the park was settled in the 1820s by French colonists.

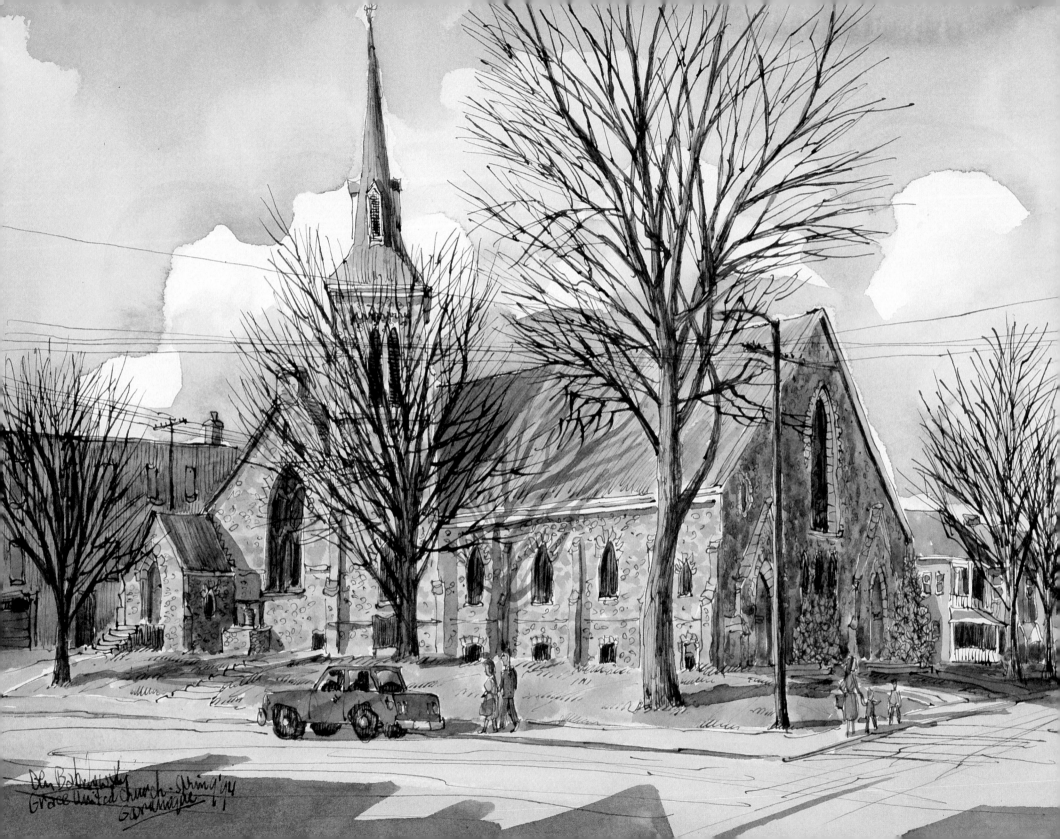

Glen Bakewhat
Grace United Church - Spring '74
Carnaydec

Victoria Woollen Mill, Almonte

This odd-shaped stone building at the foot of Almonte's main street has changed names several times since it was built in 1863. Originally called the Victorian Woollen Mill, the five-storey building along the Mississippi River later became the Shoddy Mill, where felt was made from leftover wool.

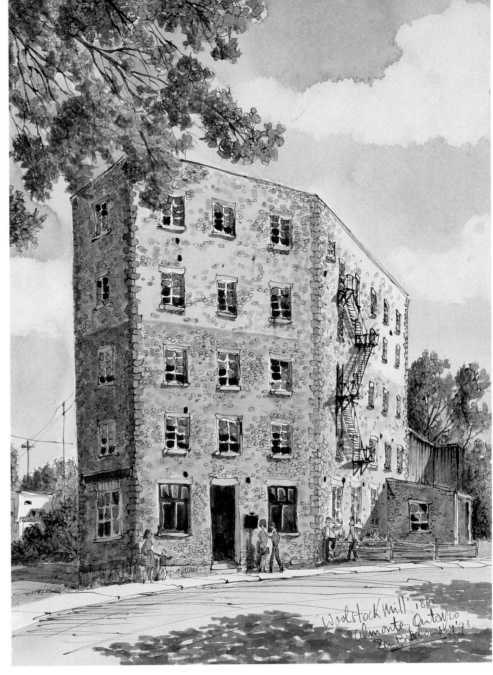

Grace United Church

The stone walls of this Gananoque church near Kingston were all that was left standing when a fire gutted the parish in 1979. Built originally in 1871, each stone was taken down, marked and put back up when the building was reconstructed in 1981. The original bell now sits on the front lawn on the corner of Pine and Stone streets.

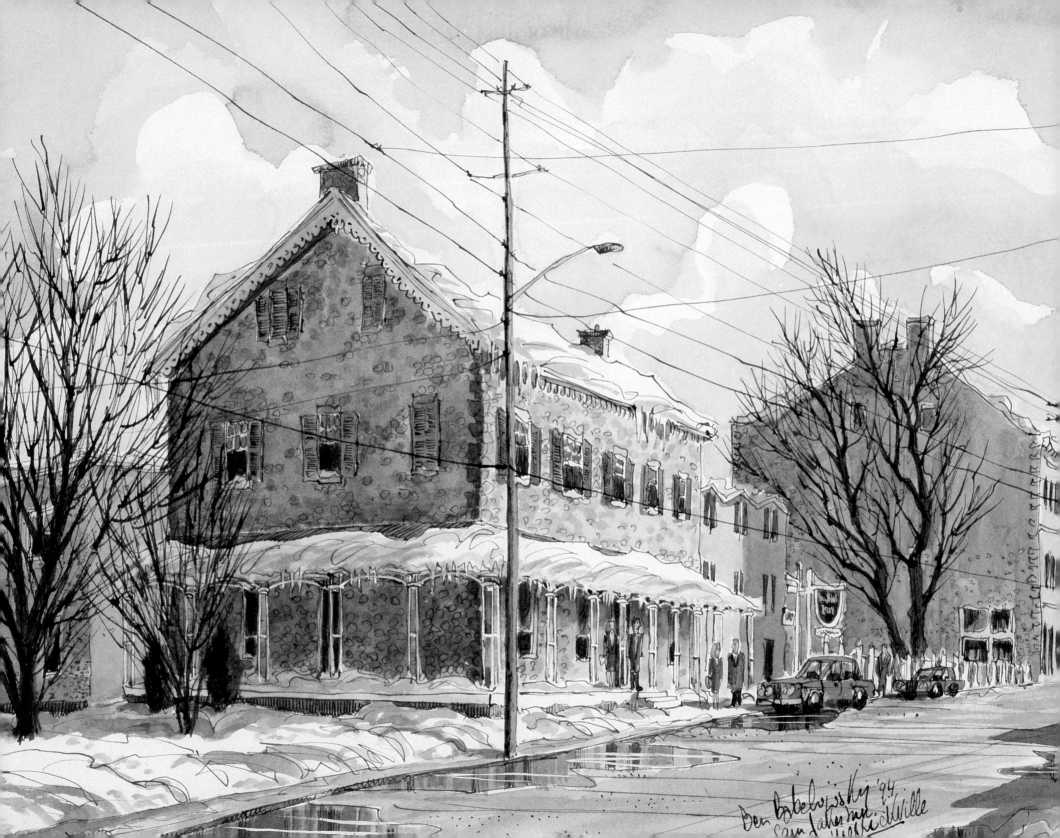

Ben Babelowsky '94
Caus Lahenser Mitchville

Boulton Brown Mill, Carleton Place

This luxurious condominium building overlooking the falls of the Mississippi River began as a grist mill in the 1820s. Just a few doors down from the town hall, the Mill Street building was constructed by Hugh Boulton in 1823 and served an area as far north as Arnprior.

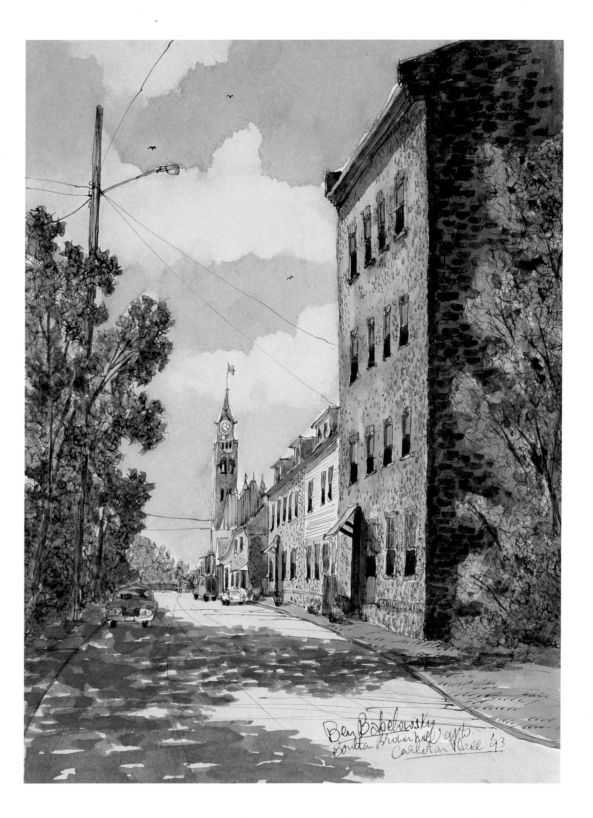

Sam Jakes Inn, Merrickville

Long before this stone building became a country inn, it was home to Sam Jakes, an Irish immigrant and successful merchant. Jakes moved into the house in 1861 and it remained in his family until the 1930s. From the 1950s to late 1980s, it served as an inn.

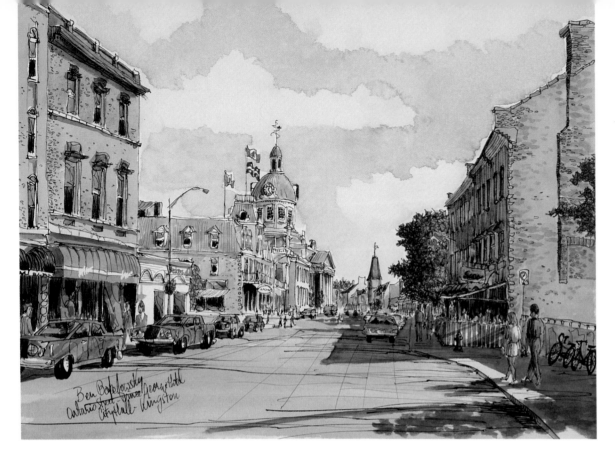

Ontario Street, Kingston

The domed Kingston City Hall, designed by architect George Browne, was completed in 1843.

Advance Printing Ltd., Kemptville

The sandstone building on the right side of this sketch houses Advance Printing, which has been publishing The *Kemptville Advance* since 1855.

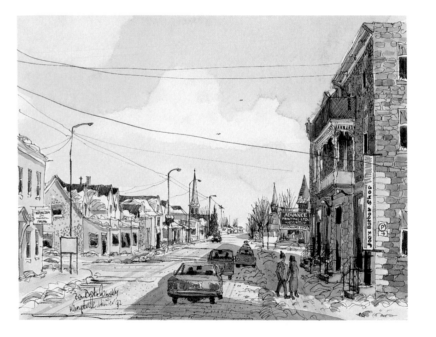

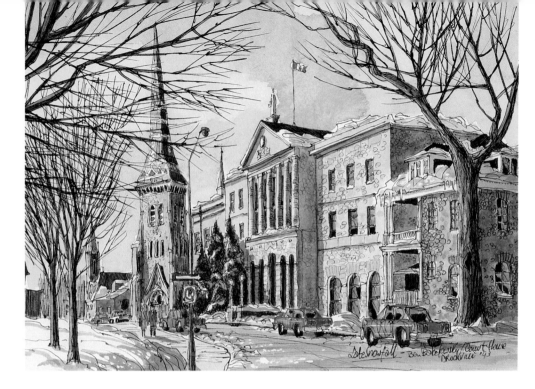

County Courthouse, Brockville

Built in 1842, this stone courthouse in downtown Brockville is one of Ontario's oldest public buildings.

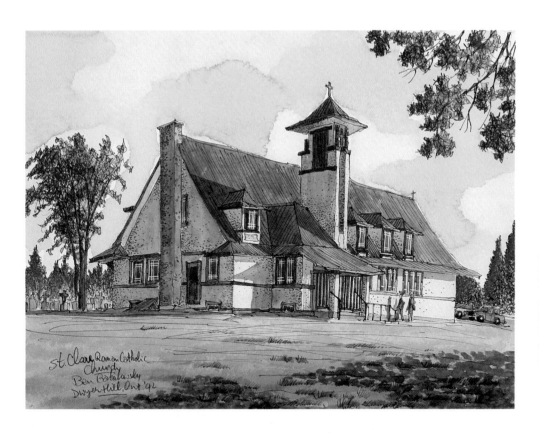

St. Clare Roman Catholic Church, Dwyer Hill Road

The cornerstone of this church, designed by architect Francis C. Sullivan, was laid in 1915. Sullivan, who also designed the horticulture building at Lansdowne Park, was a student and employee of American architect Frank Lloyd Wright.

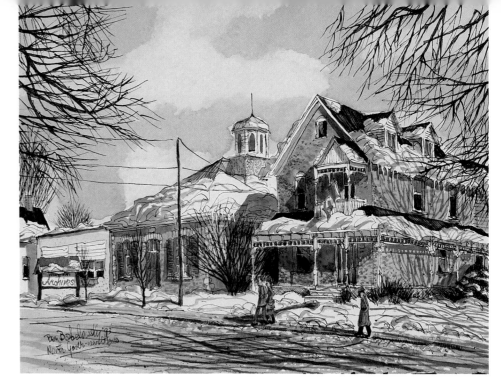

Rideau Township Archives

This one-storey brick building in the village of North Gower has, over the years, been a municipal office, dance hall and garage for the local volunteer fire department. It was built in 1876 by area farmer and contractor John A. Eastman

Ontario Hall, Queen's University

Originally home to the physics department, this early 1900s limestone building was used for geography studies from the 1950s to 1970s.

Courtesy Mr. Brian Hickman

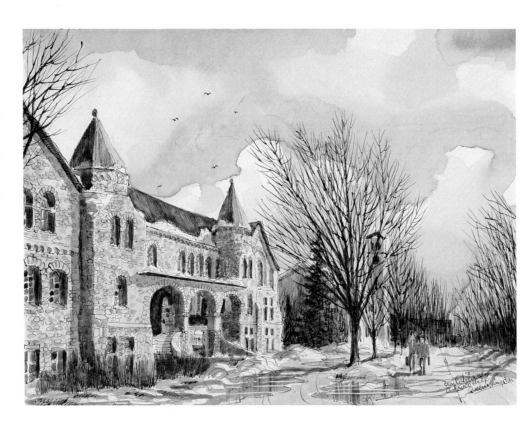

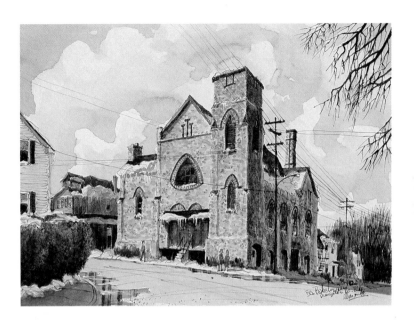

Dungarran Company Building, Almonte

Built in 1887, the building served as a Methodist then United church until 1951. It housed several unsuccessful businesses over the years. Today, the building is vacant.

King and Stone streets, Gananoque

The building at the corner of King and Stone streets was erected in 1856 and known as Cheever House. Today it is known as the Stone Street Café.

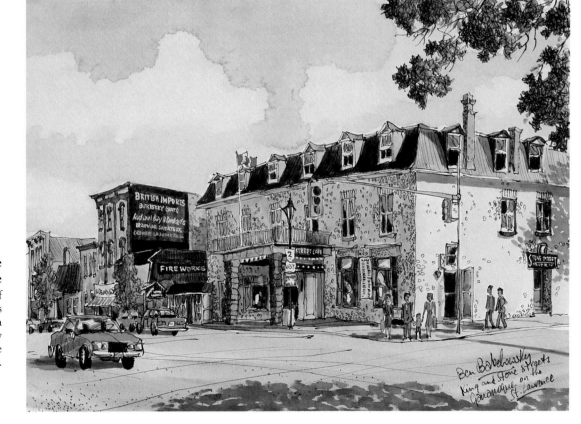

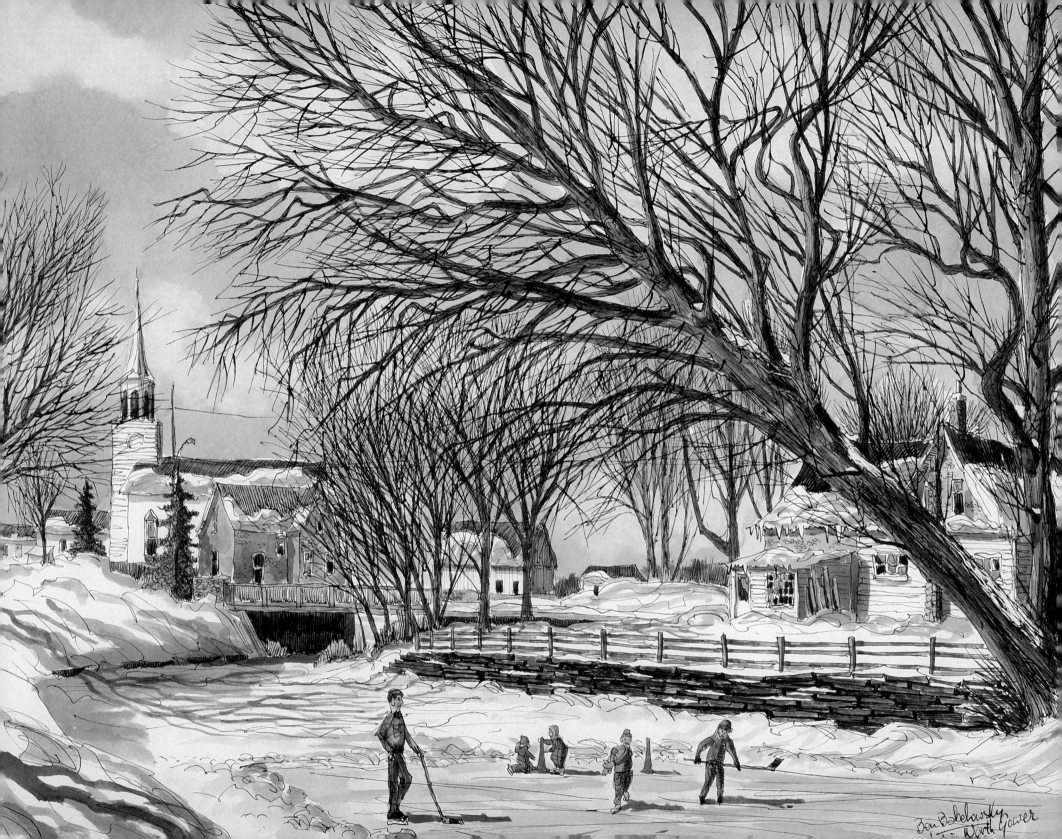

Ben Babelowsky
North Gower

"LOCALES": ROAMING THE CITY

◆ ◆ ◆

Valley people don't have a monopoly on nostalgia. **Citizen** *readers from the Glebe, Overbrook, Nepean, Vanier, Kanata, Orleans … they all have their favorite city scenes. They guide me to interesting old schools, bridges, stores, heritage buildings and, of course, churches. I have enough requests to last me for years.*

Stevens' Creek, North Gower
North Gower United Church provides the backdrop for these skaters on
Stevens' Creek in North Gower.

Courtesy Wackid Radio

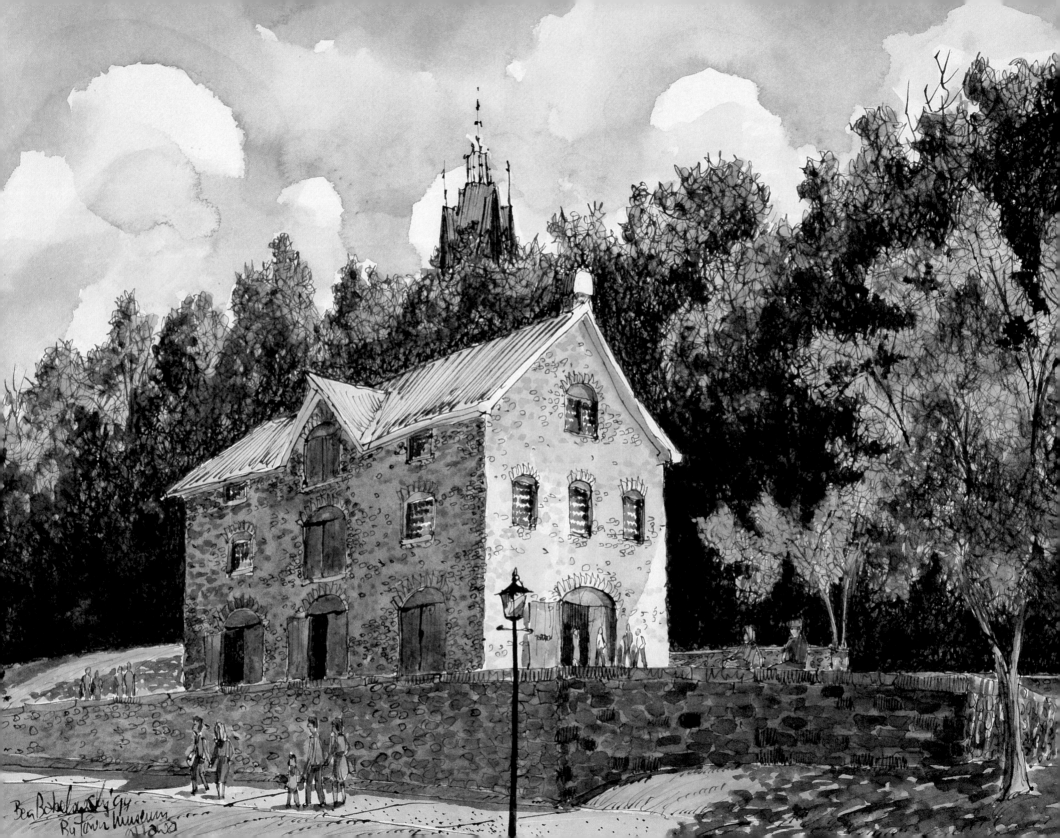

Bea Bobal...'94
Bytown Museum
Ottawa

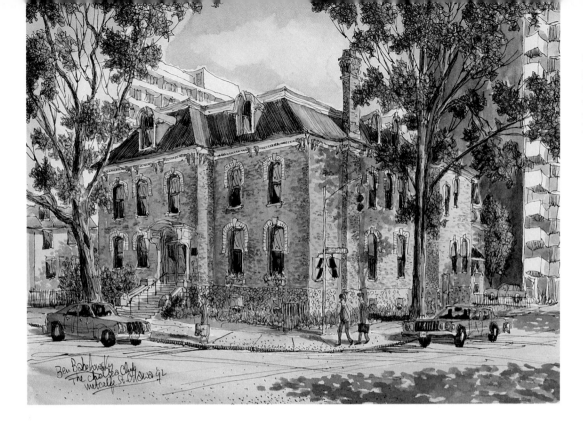

Chelsea Club, Metcalfe Street

Sir Alexander Campbell, Sir John Carling and Sir Louis Henry Davies had more in common than their knighthoods. All three once lived in this massive heritage house on the corner of Metcalfe and Somerset.

Commonwealth Club International, 303 Frank St.

This elegant Victorian mansion between Metcalfe and O'Connor streets has been a private club for more than 35 years. It was built in 1885 as an elite doctor's home.

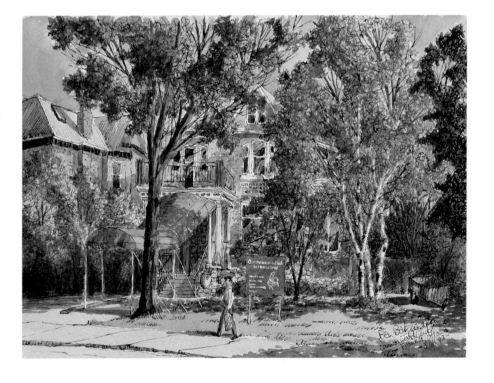

Bytown Museum

Constructed in 1827 as an office, storehouse and treasury for the builders of the Rideau Canal, the Commissariat — better known as the Bytown Museum — is Ottawa's oldest masonry building. The limestone edifice, between Parliament Hill and the Chateau Laurier Hotel, hides a roomy interior and dozens of displays on Lt.-Col. John By's military and home life.

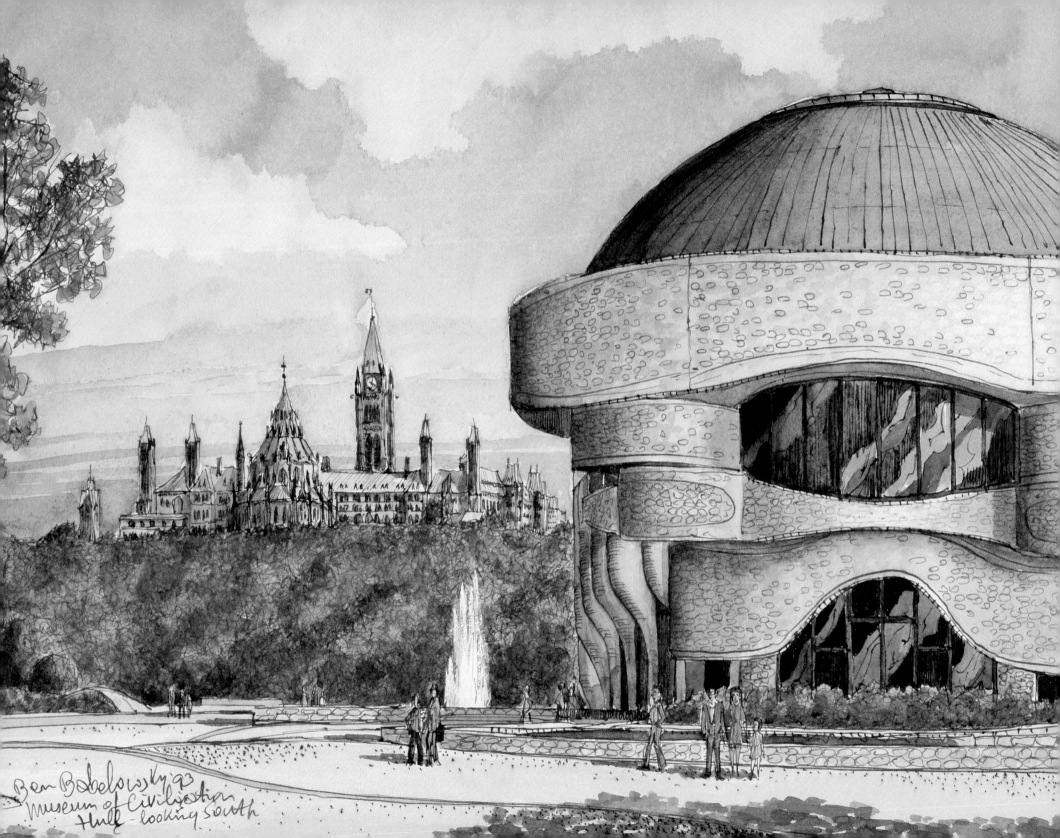

Ben Babelowsky '93
Museum of Civilization
Hull - looking south

Connaught Building, MacKenzie Avenue

This large turreted building on MacKenzie Avenue near Major's Hill Park was built in 1914. It has been home to the Department of National Revenue ever since.

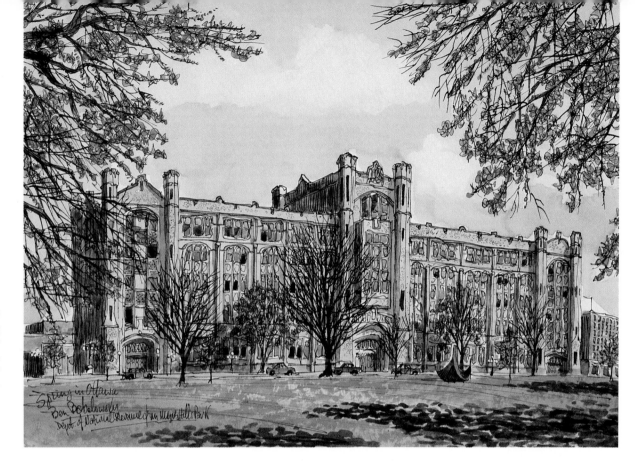

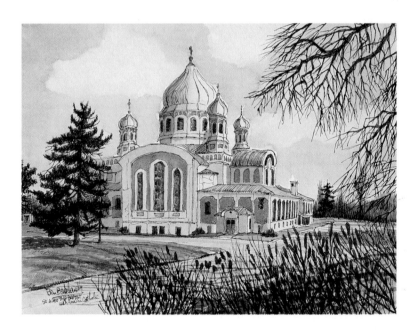

Canadian Museum of Civilization, Hull

Designed by architect Douglas Cardinal, the curvaceous stone building is one of the most popular tourist attractions in the region. The 100,000-square-metre structure sits on 24 acres along the Ottawa River.

Ukrainian Catholic National Shrine

Designed by Julian Jastremsky of New York with five domes and windowed walls, this magnificent church features a mix of modern and traditional Ukrainian architecture.

Corner of George and Dalhousie

Named the "Mercury" building, after the figure perched on top of the green dome, the building stretches from Rideau to George streets.

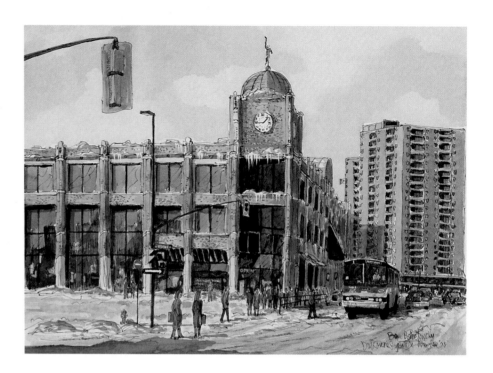

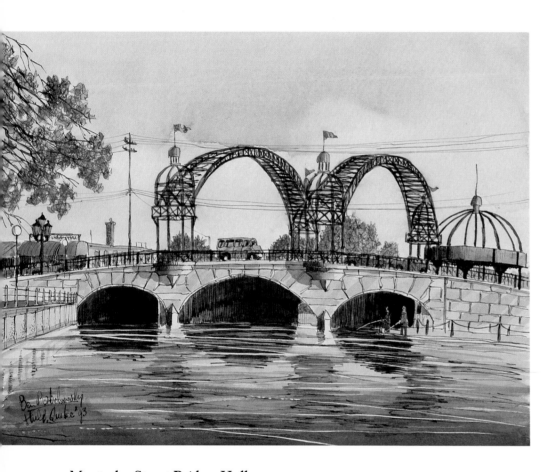

Montcalm Street Bridge, Hull

Does this look like a scene from Paris? It should, because this Hull bridge was designed with the Eiffel Tower in mind. Built in 1990, the bridge is an elegant link to the Outaouais.

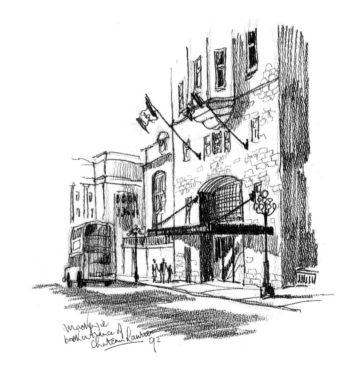

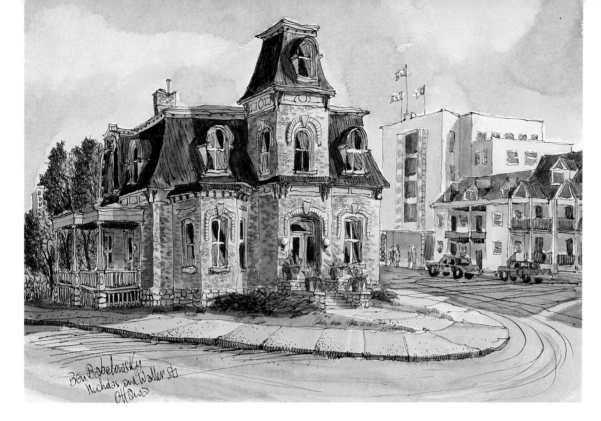

195 Nicholas Street, Ottawa

This stately red brick home was built in 1883-84 by Horace C. Odell, a brick mason and brickyard owner, as a wedding gift for his son, Clarence.

Aylmer Monastery

This stone residence was built on 30 acres of land by timber magnate John Egan in the 1840s. Egan, who founded Aylmer, held many lavish parties in his home, entertaining the likes of Lord Elgin.

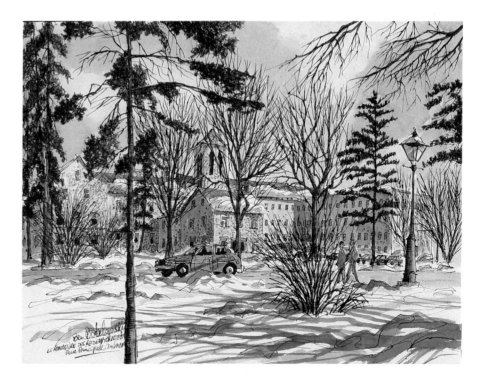

First Church of Christ Scientist, 288 Metcalfe St.

Designed by architect John Pritchard MacLaren, and built with Ohio sandstone, this church is considered a good local example of neo-classical architecture.

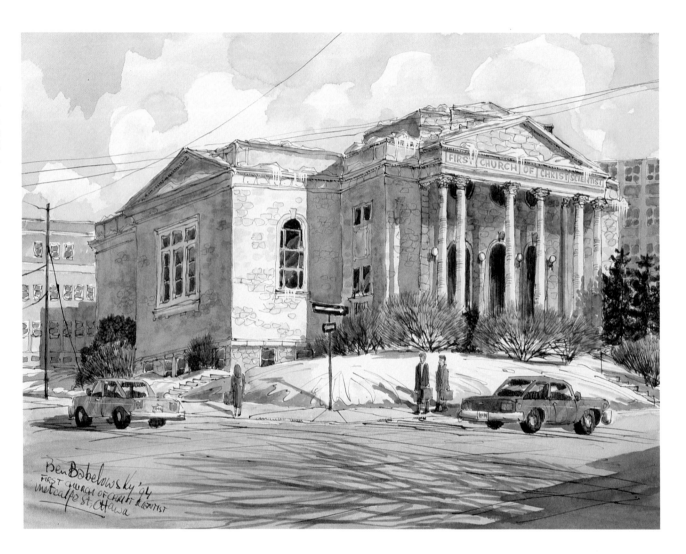

Teale Terrace, Queen Elizabeth Driveway

This award-winning heritage building on the Queen Elizabeth Driveway is one of Ottawa's most stunning landmarks. Built in 1907, the elaborate brick row between First and Second avenues is a mix of towers, arches, domes and pyramids.

Courtesy Mr. Greg Weston

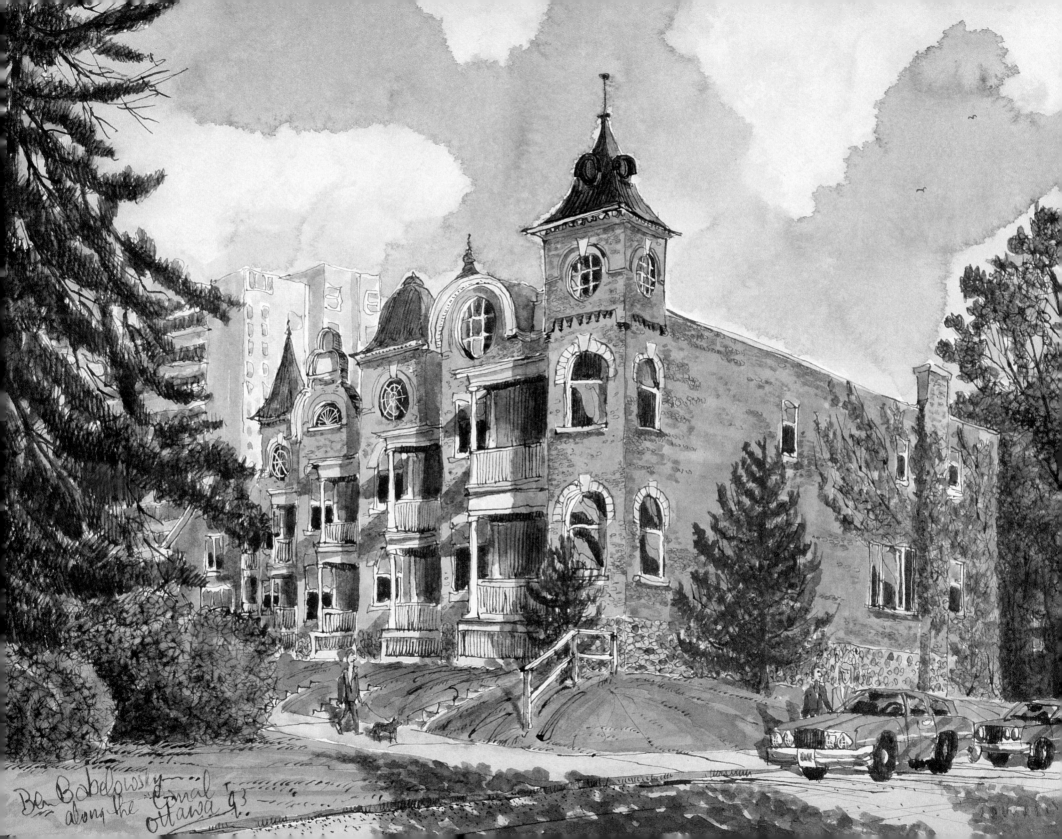

Ben Babelowsky
along the "canal"
Ottawa 93.

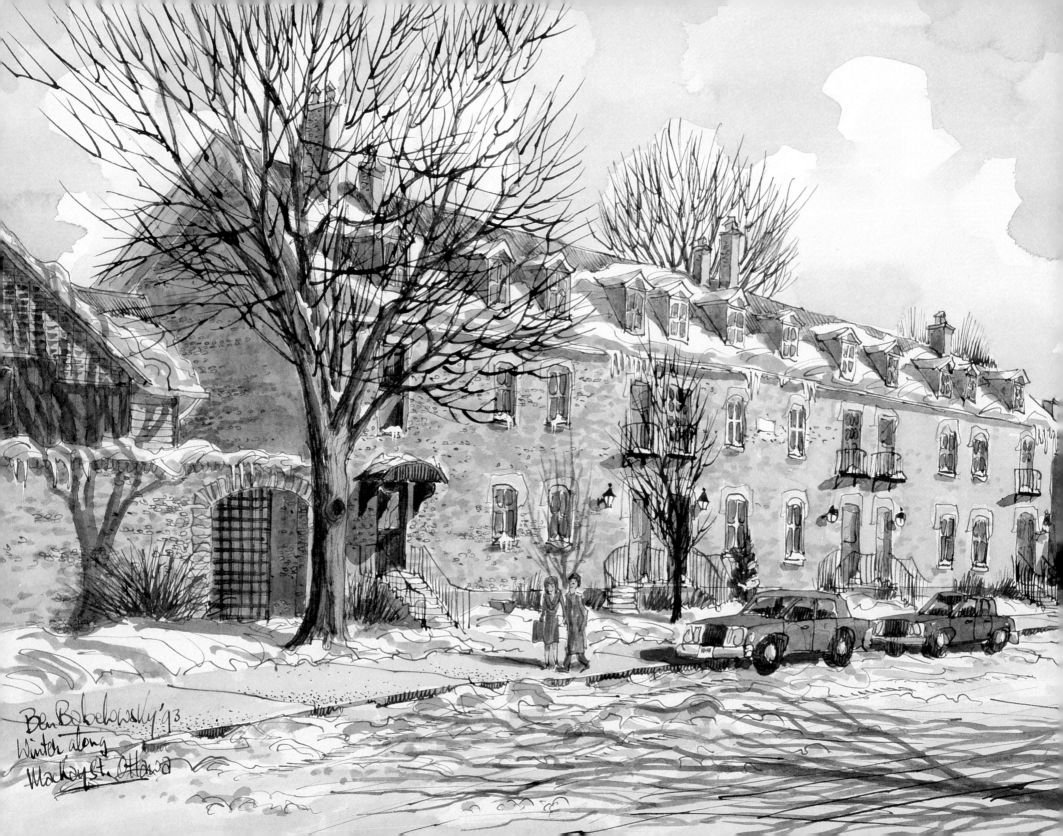

Ben Babelowsky '93
Winter along
Mackay St. Ottawa

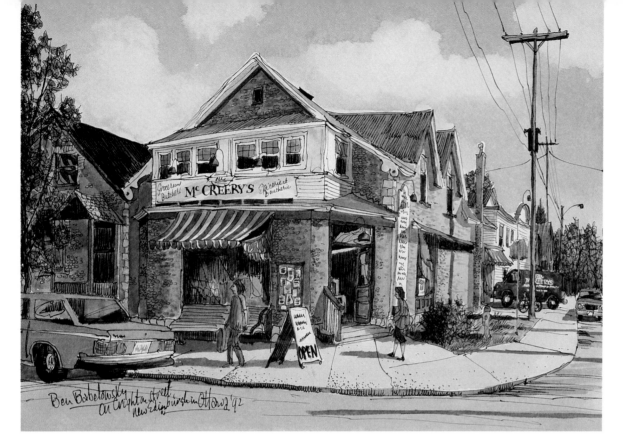

McCreery's Grocers & Butchers, New Edinburgh

This well known corner store dates back to the late 1800s. Today, under a new name, it continues as a traditional neighborhood store.

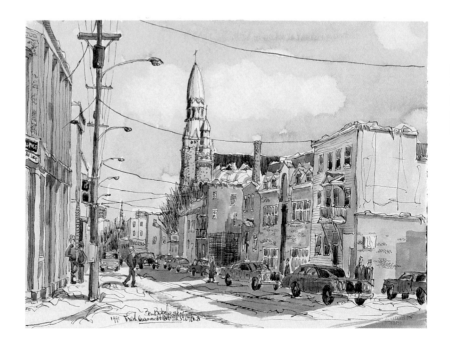

St. Patrick Street

The distinctive steeple of St. Brigid's church dominates the skyline along this busy Lowertown street.

Lansdowne Terrace, MacKay Street

These historic brick rowhouses in New Edinburgh are reminiscent of the upper middle-class village's early mill days.

Courtesy Mr. and Mrs. Dave Ireland

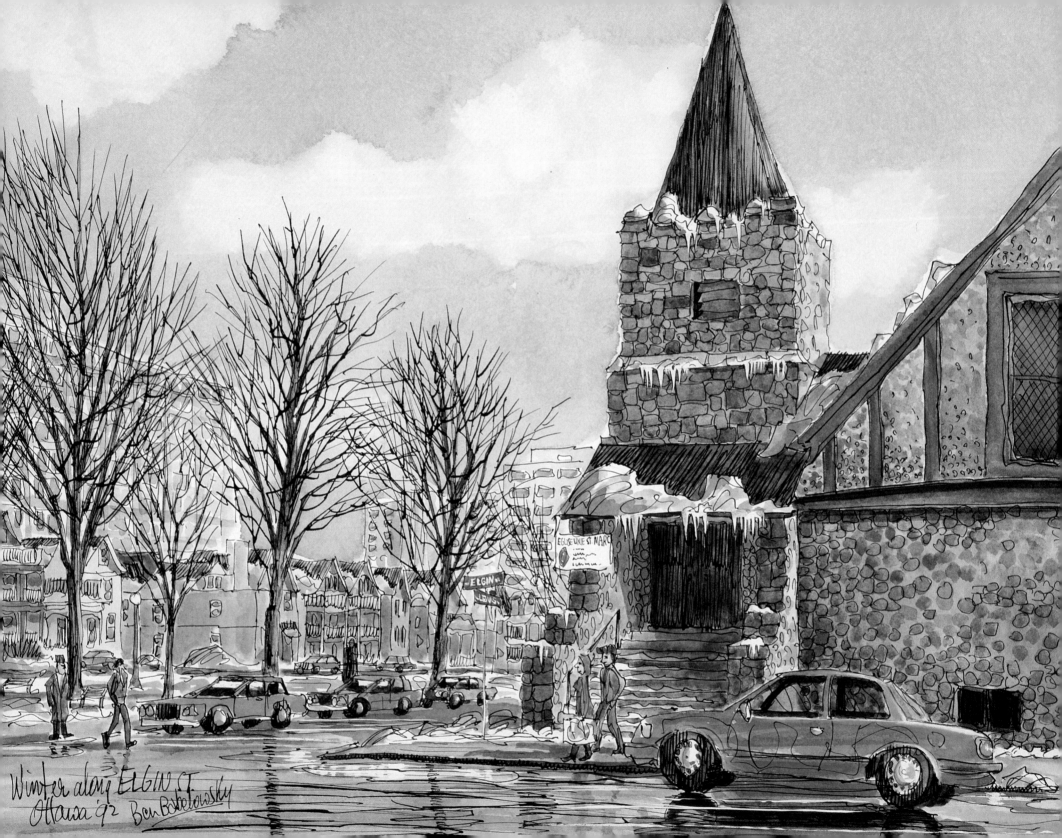

Winter along ELGIN ST.
Ottawa '92 Ben Babelowsky

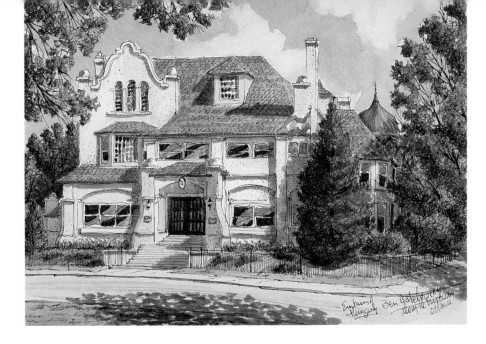

Embassy of Hungary

Built in the 1920s, this enormous house along the Driveway at Delaware Avenue has been home to the Hungarian embassy for the past 30 years.

National Research Council

Designed after the public buildings of France, this stately neo-classical building at 100 Sussex Dr. became the headquarters for the Crown corporation in 1932.

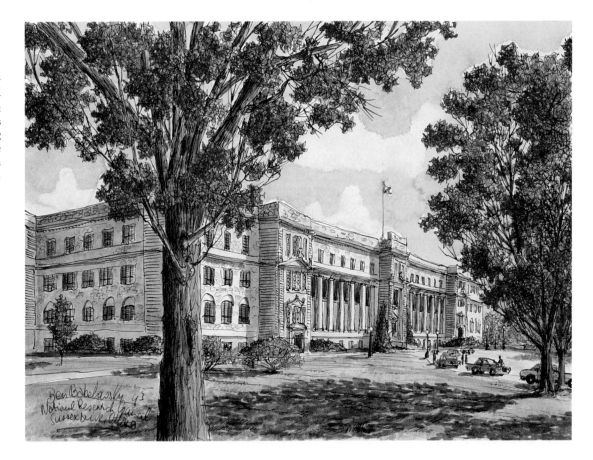

Église Unie St. Marc

The church on the southeast corner of Elgin and Lewis, built in 1900, was first a Unitarian church. The congregation of St. Marc took over in 1965, after the federal government expropriated the land their church occupied on Wellington Street.

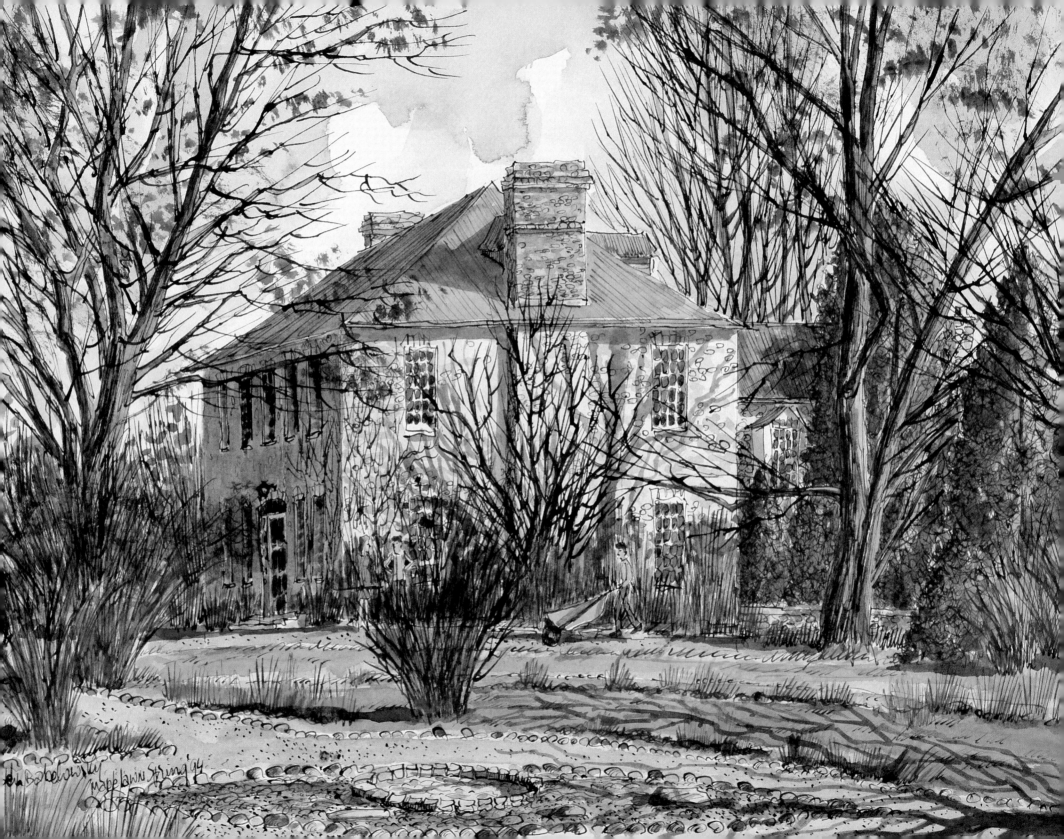

Maplelawn, 529 Richmond Rd.

Named one of Canada's top heritage buildings in 1987, this 160-year-old stone building was once home to Ottawa's prominent Rochester family. Owned by the National Capital Commission, the Georgian-style house boasts one of the oldest private walled gardens in Canada.

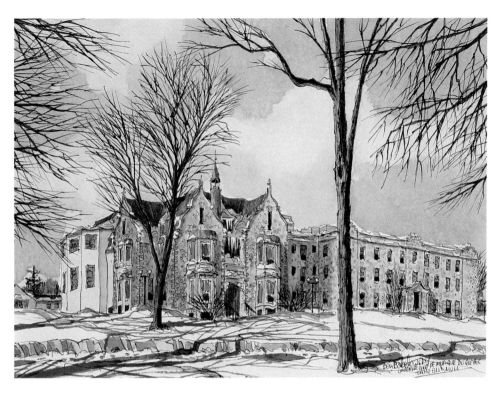

Hull Conservatory of Music

This stone building at 430 Taché Blvd. in Hull has been home to the provincial conservatory since 1987.

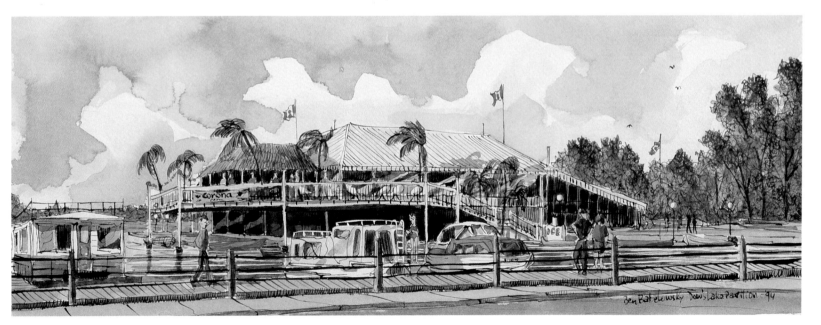

Dow's Lake Pavilion, Queen Elizabeth Driveway

This odd-shaped complex overlooking the man-made lake is a busy, year-round gathering place. Built in 1982-83, the pavilion offers refuge in winter to canal skaters and a cool pitstop for paddleboaters and strollers in summer.

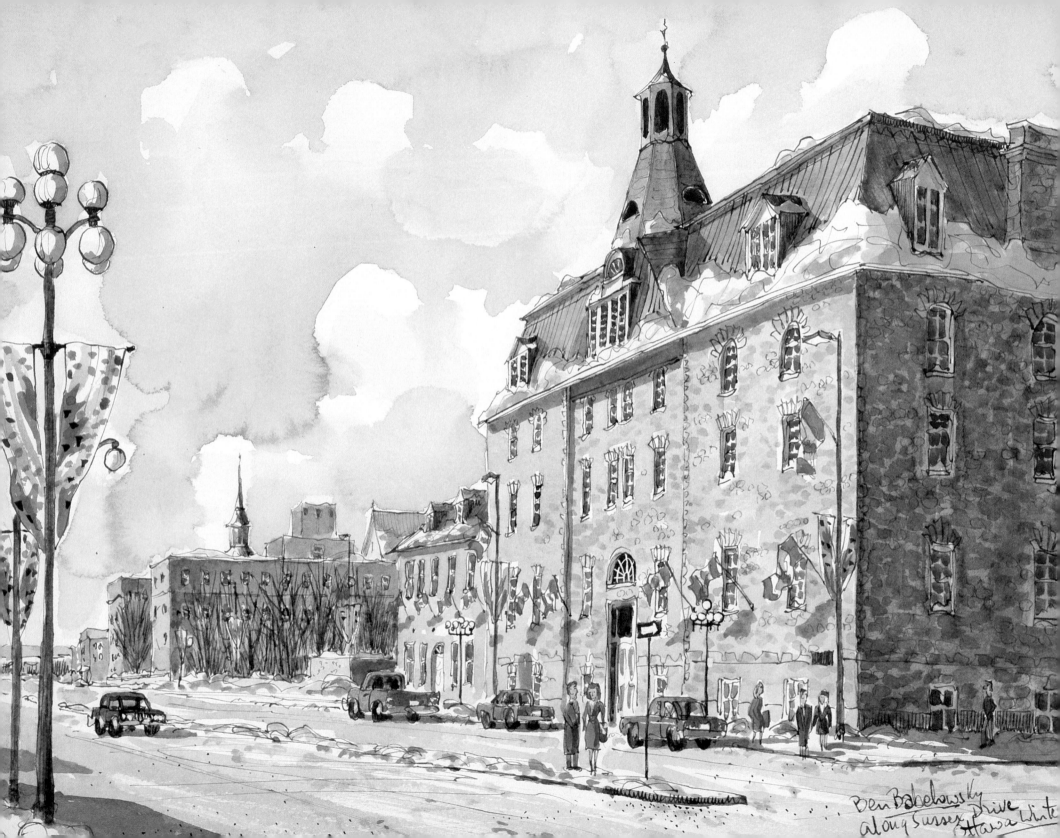

Ben Babelowsky
along Sussex Drive
Ottawa White

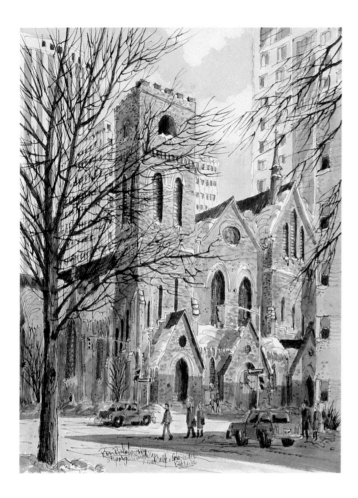

St. George's Anglican Church

A spire once graced this church at 152 Metcalfe St. But after being hit by lightning twice, the peak was capped just above the bell tower. Originally a Methodist parish, it was built in 1883.

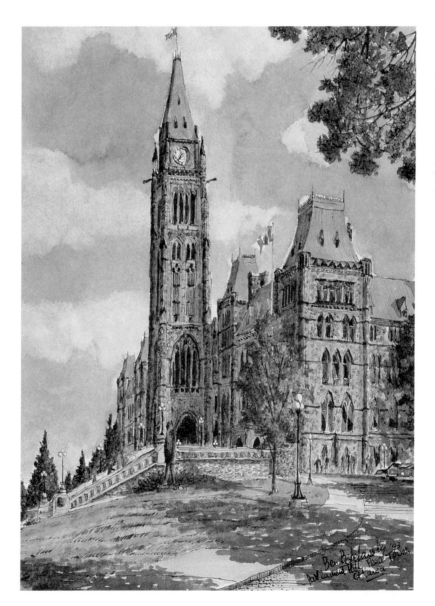

The Peace Tower

Completed in 1927, Ottawa's most famous landmark houses a huge clock, public lookout and 53-bell carillon which is sounded daily. Originally called the Victory Tower, it was dedicated to peace in 1933.

373 Sussex Drive

Built in 1882, this building across from the National Gallery was Ottawa's first major school. Named Collège de Bytown, it was run by the Oblate order and open to both Catholics and Protestants.

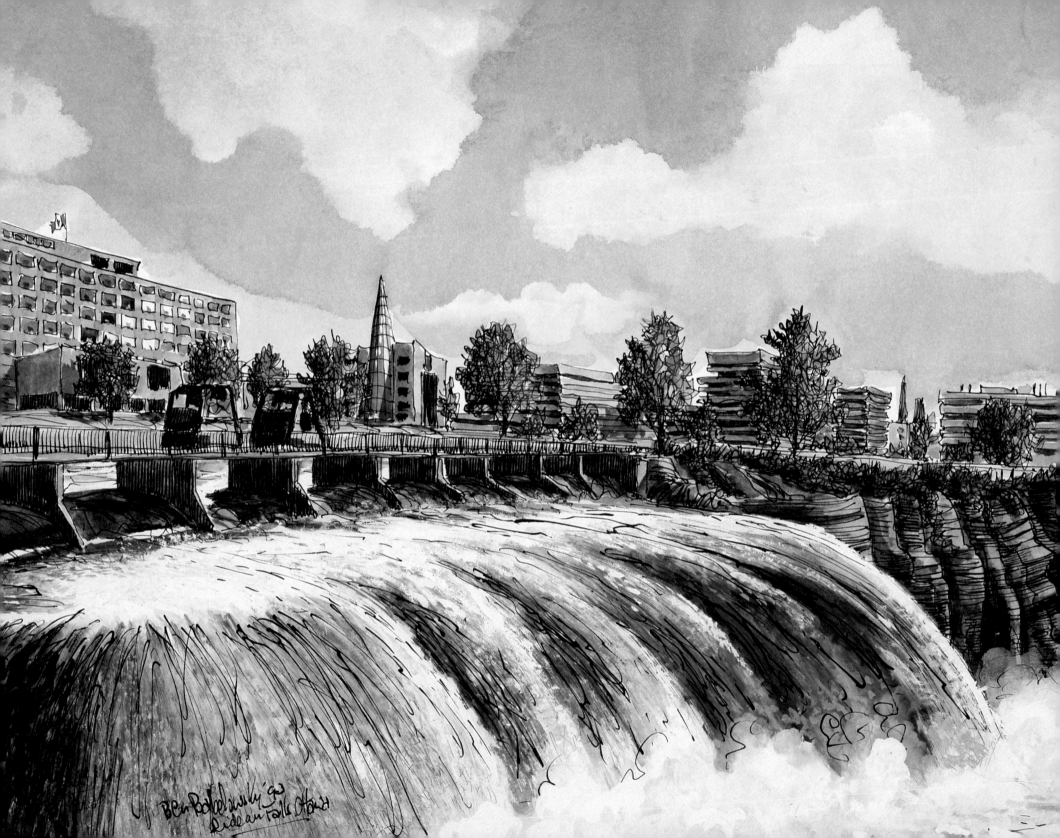

Ben Babelowsky '89
Rideau Falls Ottawa

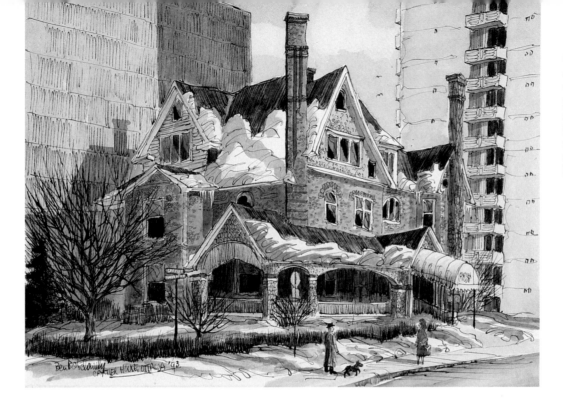

Cartier House, 46 Cartier St.

This enormous, red brick home at the corner of Cartier and Somerset streets has been a private inn for the past eight years. The three-storey building was built in 1901.

Corner of St. Patrick Street and Sussex Drive

The grey stone building on the right was built around the 1860s. It was home to Dr. François Xavier Valade, the physician who examined Louis Riel before his trial in 1885 to determine whether the French patriot was insane.

Courtesy Mrs. Thérèse LeMay-Caron

Rideau Falls, Sussex Drive

Early French explorers called this rushing water-fall Rideau, because it looks like a sheer curtain across the face of the cliff. Jean-Baptiste St-Louis was the first to harness the power of the falls when he built a sawmill by them in 1832.

281 Echo Drive

For more than 60 years, this enormous brick building overlooking the Rideau Canal has been home to one school after another. In 1994 it became the new location for Immaculata High School.

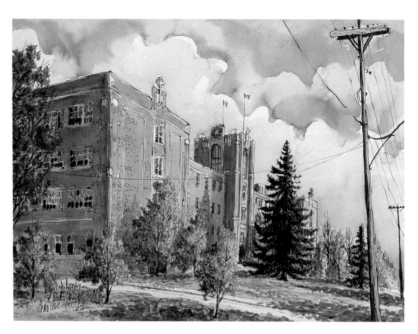

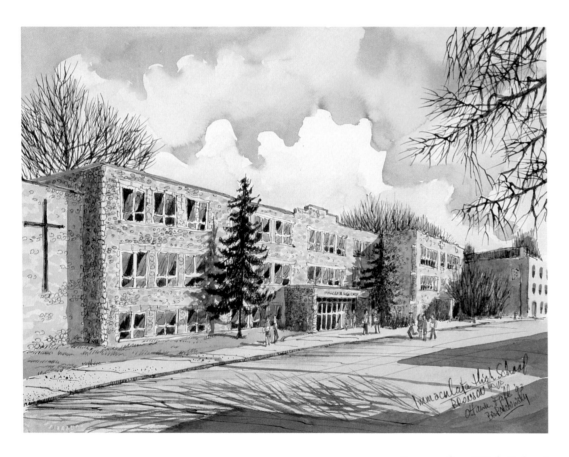

Immaculata High School

After 65 years under this roof, the private Catholic school at 211 Bronson Ave. has moved. It is now in old St. Pat's College at 281 Echo Dr. (see sketch above).

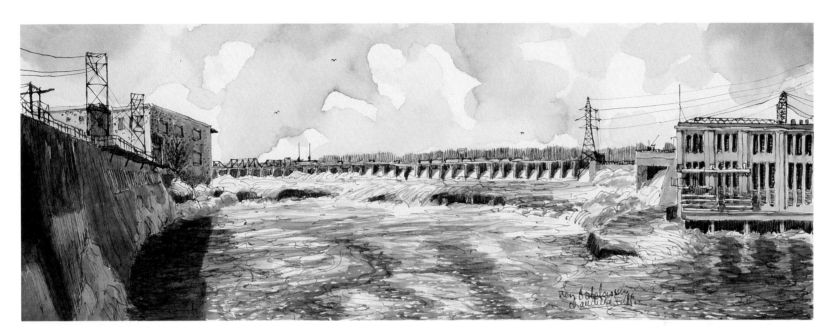

Chaudière Falls

Water used to crash and swirl over the rocks with such force that these Ottawa River falls were named chaudière, French for boiler, and later nicknamed Great Kettle. A bridge was constructed over the turbulent water — the narrowest section of the river in the area — between 1826 and 1828.

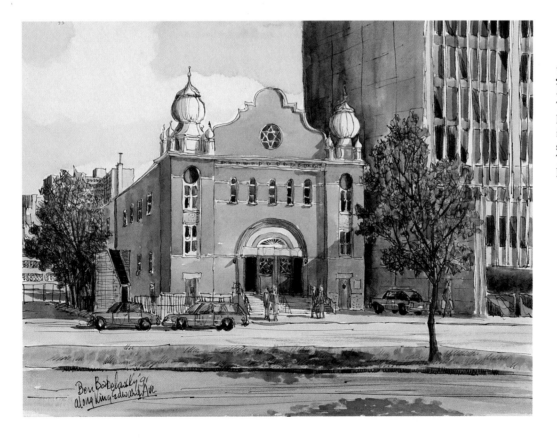

Jewish Memorial Chapel, King Edward Avenue

The Jewish Memorial Chapel at 375 King Edward Ave. was originally a synagogue. Built in 1904, it was the second in the city (the first synagogue was built in 1892 on Murray St.). The design of the building was inspired by the Byzantine architecture of the Middle East.

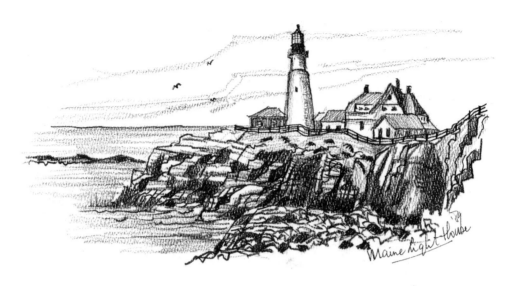

Maine Light House

FIRST IMPRESSIONS

◆ ◆ ◆

Spontaneity. That's what this is all about. Quick, impulsive and impressionistic. Working in the field with charcoal and watercolor, rain or shine — you can actually see rain drops on my page-66 sketch of Big Bear Creek. Some of the sketches were done in a boat — I still get seasick just thinking about it. The Maine and Cape Cod sketches were done sitting in the sand, mixing my watercolors with salt water — amidst tourists, screaming gulls and relentless bugs. That's living!

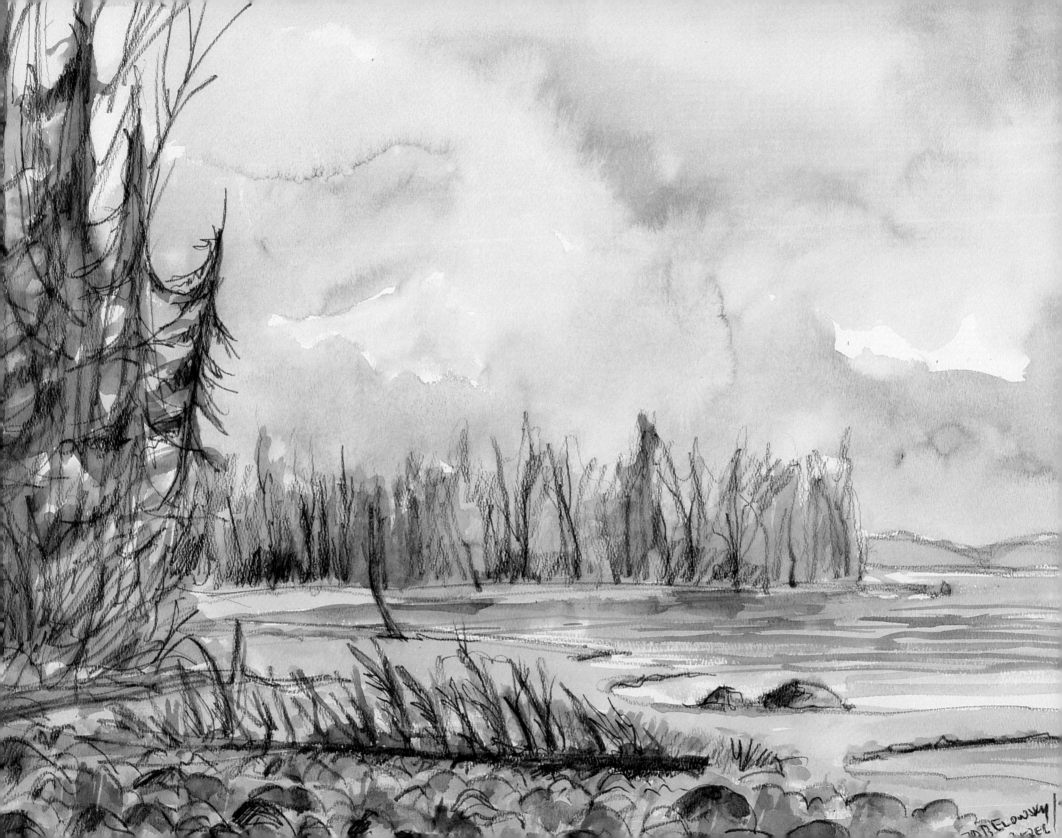

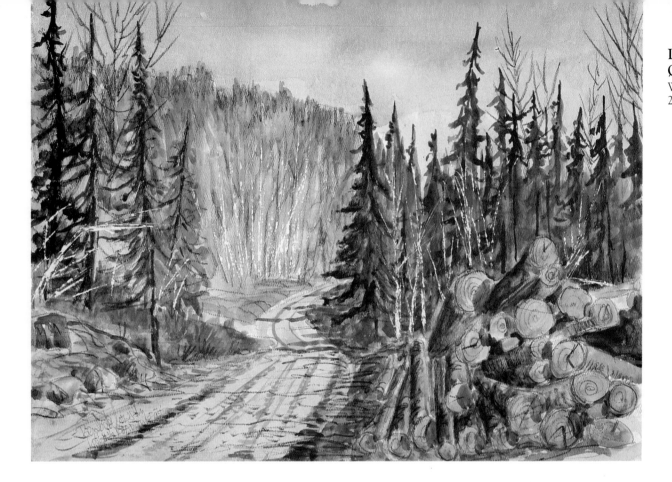

Logging road in Quebec
Watercolor and charcoal
24" x 10"

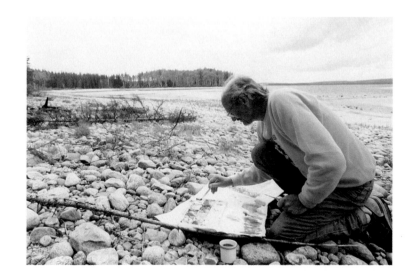

Lac Marmette
Watercolor and charcoal
24" x 18"

Courtesy Mr. and Mrs. Val Belcher

The artist working on the Lac Marmette sketch

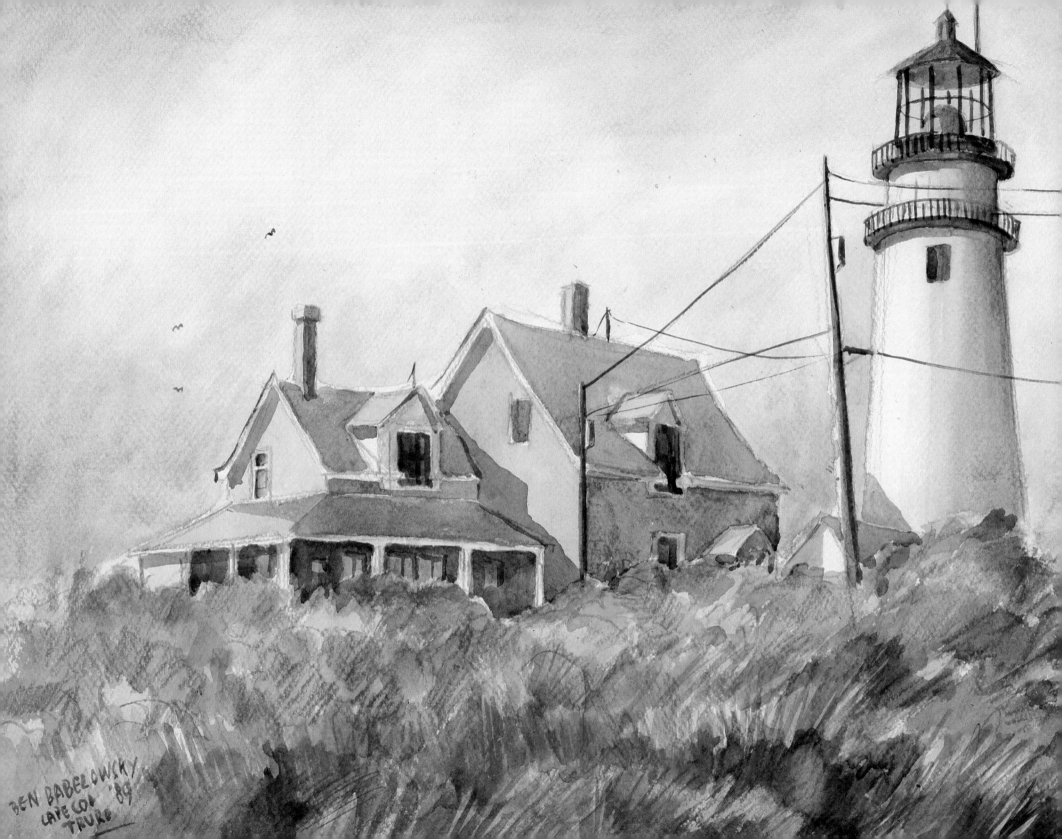

BEN BABELOWSKY
CAPE COD '89
TRURO

Cape Cod, Chatham Harbor
Charcoal and watercolor
24" x 18"

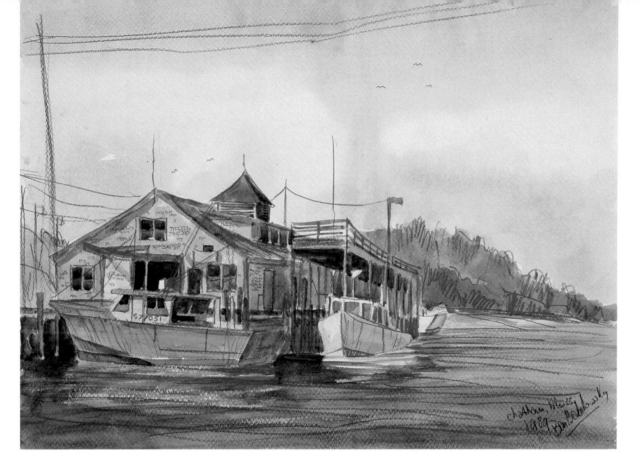

Maine, Kennebunkport boat yard
Charcoal and watercolor
24" x 18"

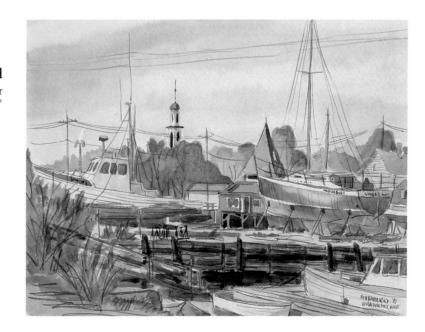

Cape Cod, North Truro Lighthouse
Charcoal and watercolor
24" x 18"

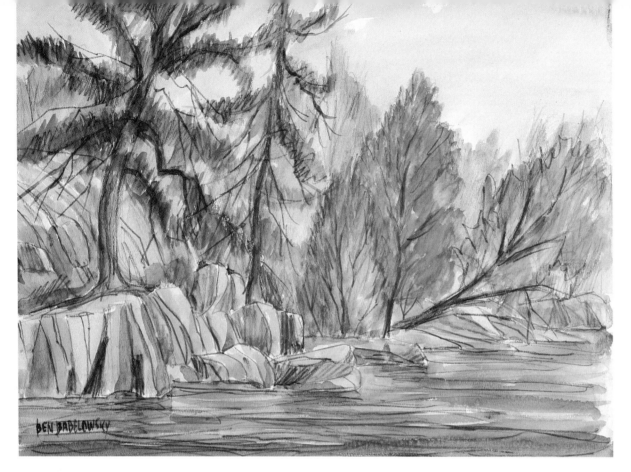

St. Lawrence River shoreline
Charcoal and watercolor
24" x 18"

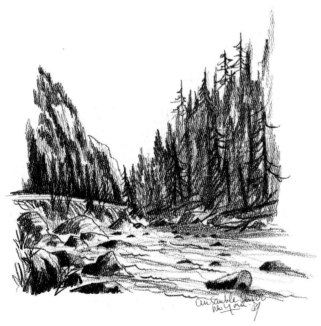

**Big Bear Creek enter-
ing the Ottawa River**
Charcoal and watercolor
24" x 18"

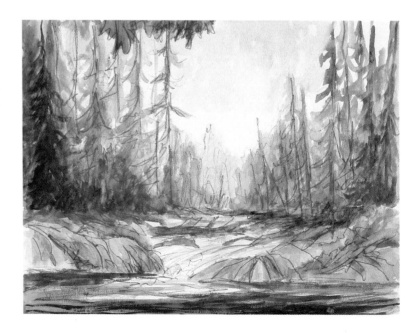

Cape Cod, Head of the Meadow Beach
Charcoal and watercolor
24" x 18"

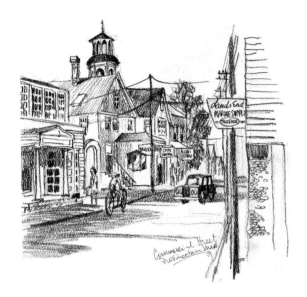

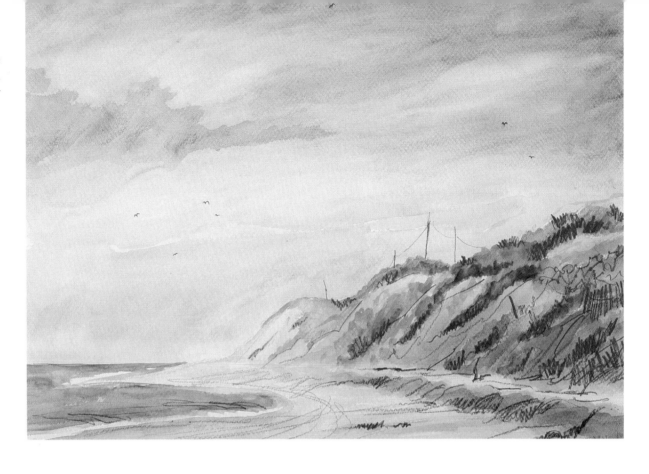

Maine, Kennebunk Beach
Charcoal and watercolor
24" x 18"

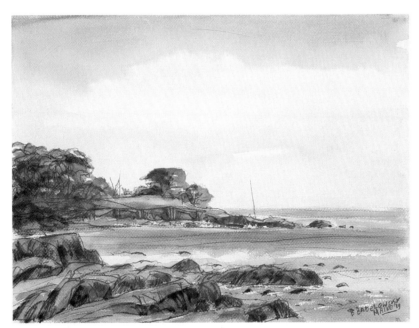

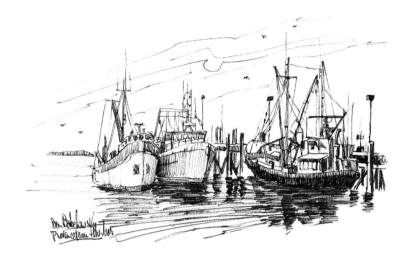

RAISING FUNDS THROUGH ART

◆　　　　◆　　　　◆

*This truly is the best of both worlds. You get to enjoy doing the art,
you help raise money for a needy cause and your work gets distributed
all over the world. There are Tall Ship prints in Russia, Rideau Canal prints
in Brazil and Ottawa River prints in South Africa. More than 700,000 limited
and unlimited edition prints later, do I have any regrets? Just one — if only I'd
had the exclusive rights to the framing concession!*

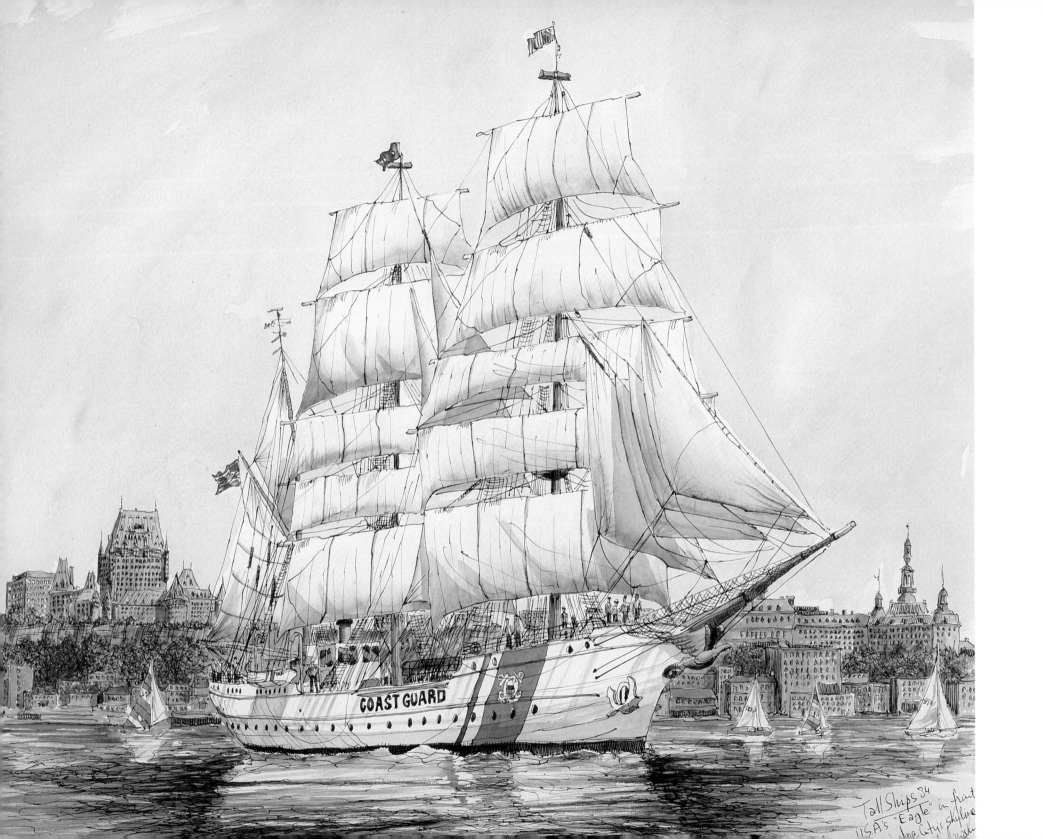

Tall Ships 84
USA's "Eagle" in front
of City's skyline

**Great Britain's
"Marques" in
Lake Ontario, 1984**
Ink and watercolor
24" x 20"

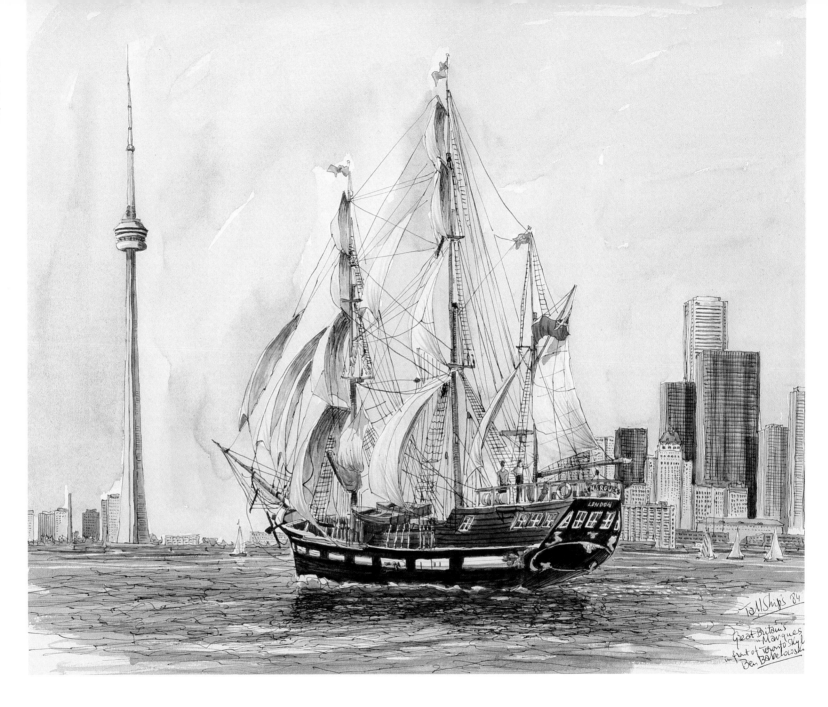

U.S.A.'s "Eagle" in front of Quebec City skyline, 1984

Ink and watercolor
24" x 20"

(All paintings in this section courtesy The Ottawa Citizen)

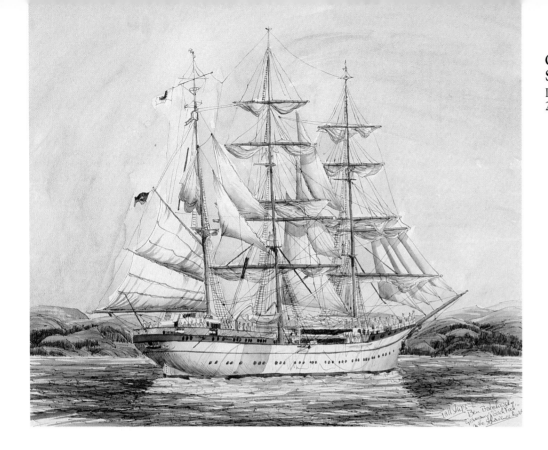

Germany's "Gorch Fock" on the St. Lawrence River, 1984
Ink and watercolor
24" x 20"

Canada's "Black Jack" in Kingston Harbour, 1984
Ink and watercolor
24" x 20"

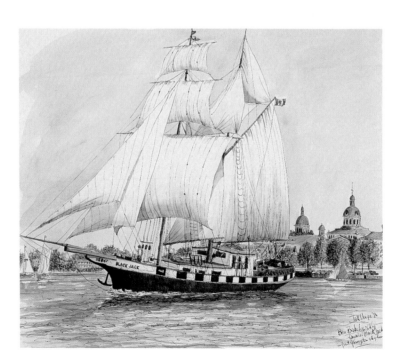

Rideau Canal Locks below the Chateau Laurier Hotel Ottawa, 1981
Ink and watercolor
24" x 20"

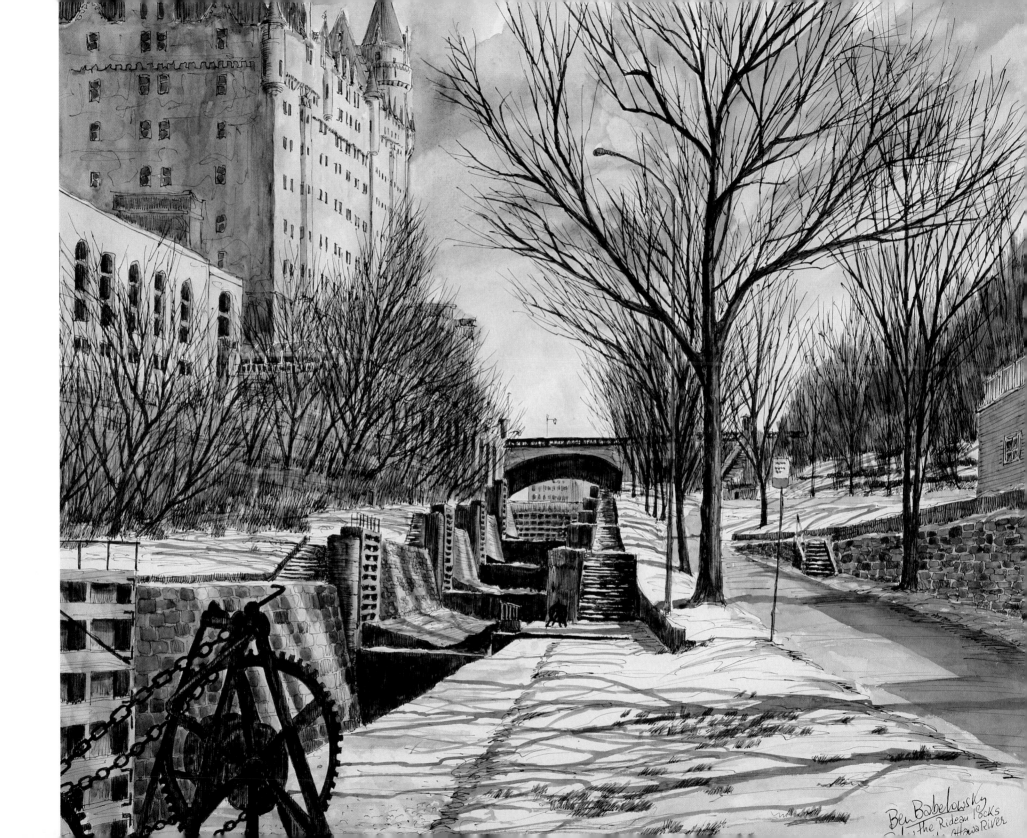

Ben Babelowsky
The Rideau Locks
At Ottawa River

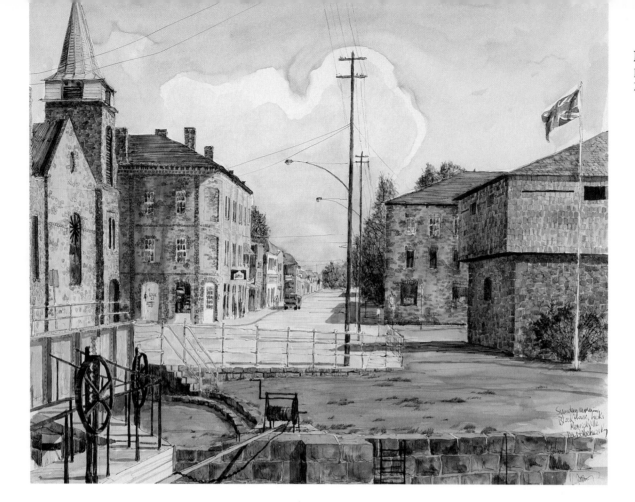

Merrickville, 1981
Ink and watercolor
24" x 20"

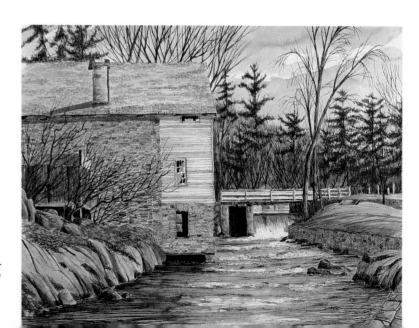

Chaffey's Lock, 1981
Ink and watercolor
24" x 20"

Kingston Mills, 1981
The artist put himself in this painting.
Ink and watercolor
24" x 20"

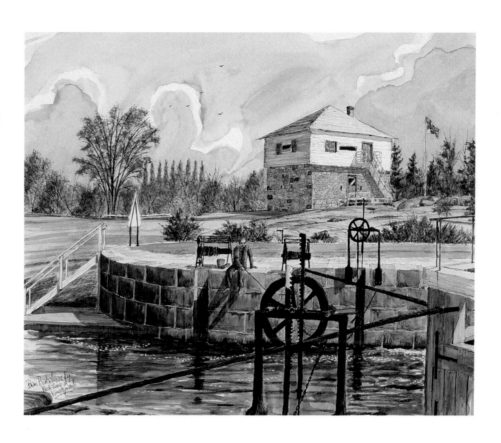

Hog's Back, Ottawa, 1981
Ink and watercolor
24" x 20"

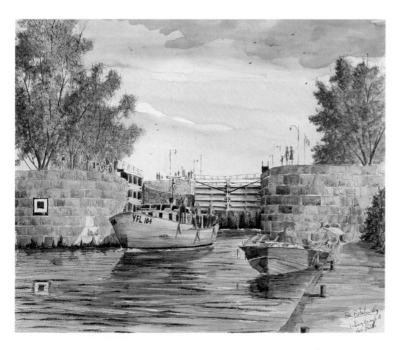

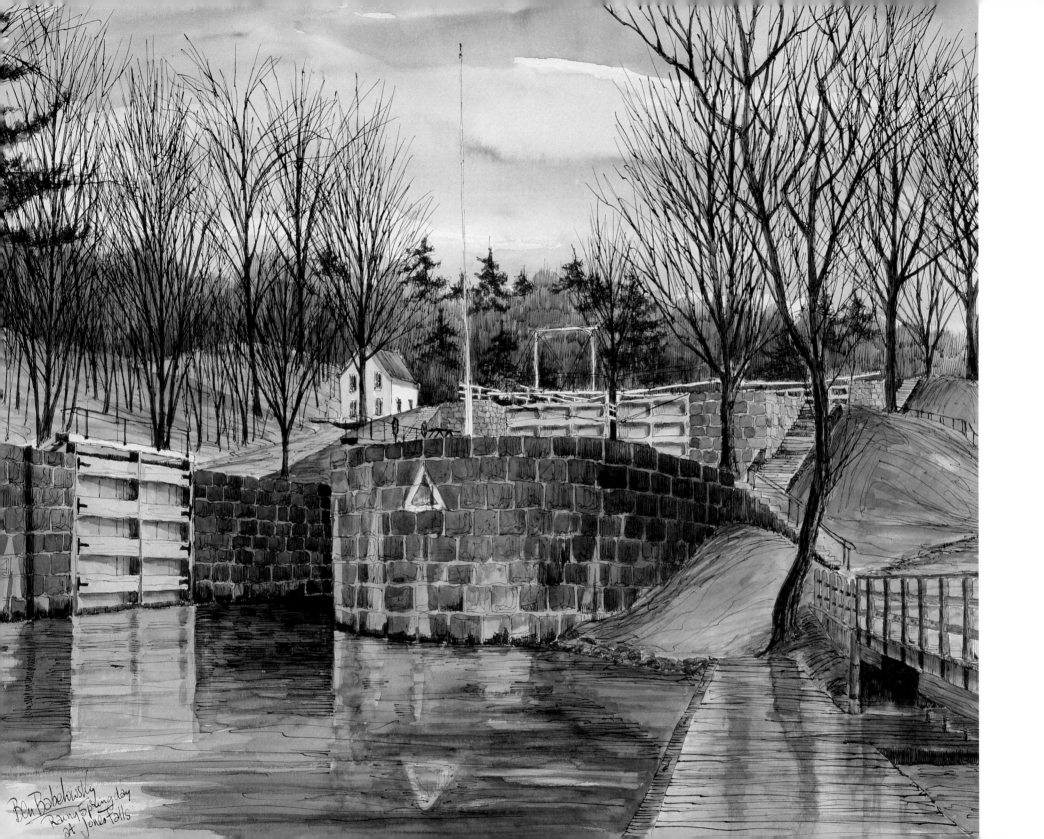

Ben Babelowsky
Rainy Spring day
at Jones Falls

Smiths Falls, 1981
Ink and watercolor
24" x 20"

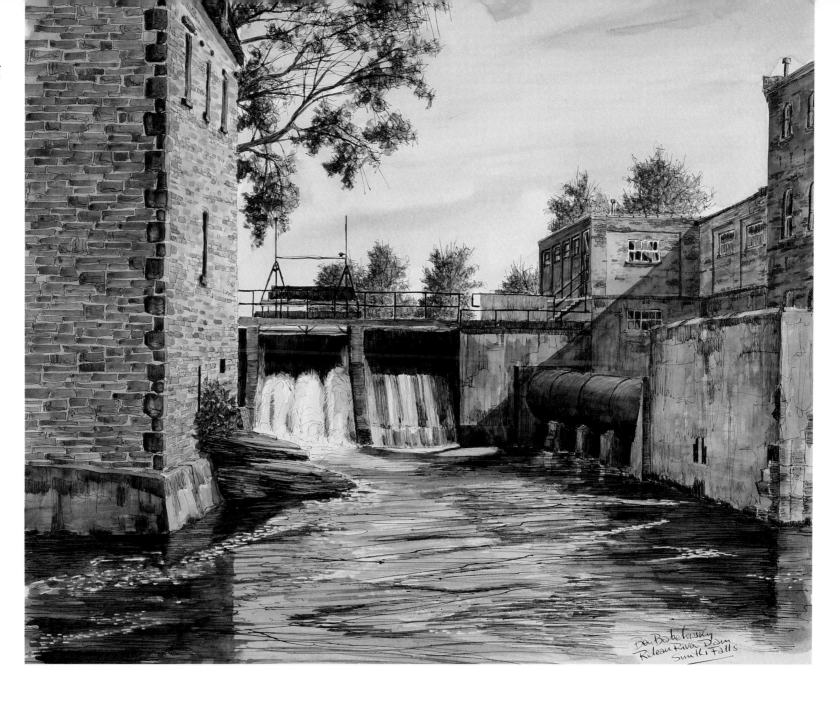

Jones Falls Locks, 1981
Ink and watercolor
24" x 20"

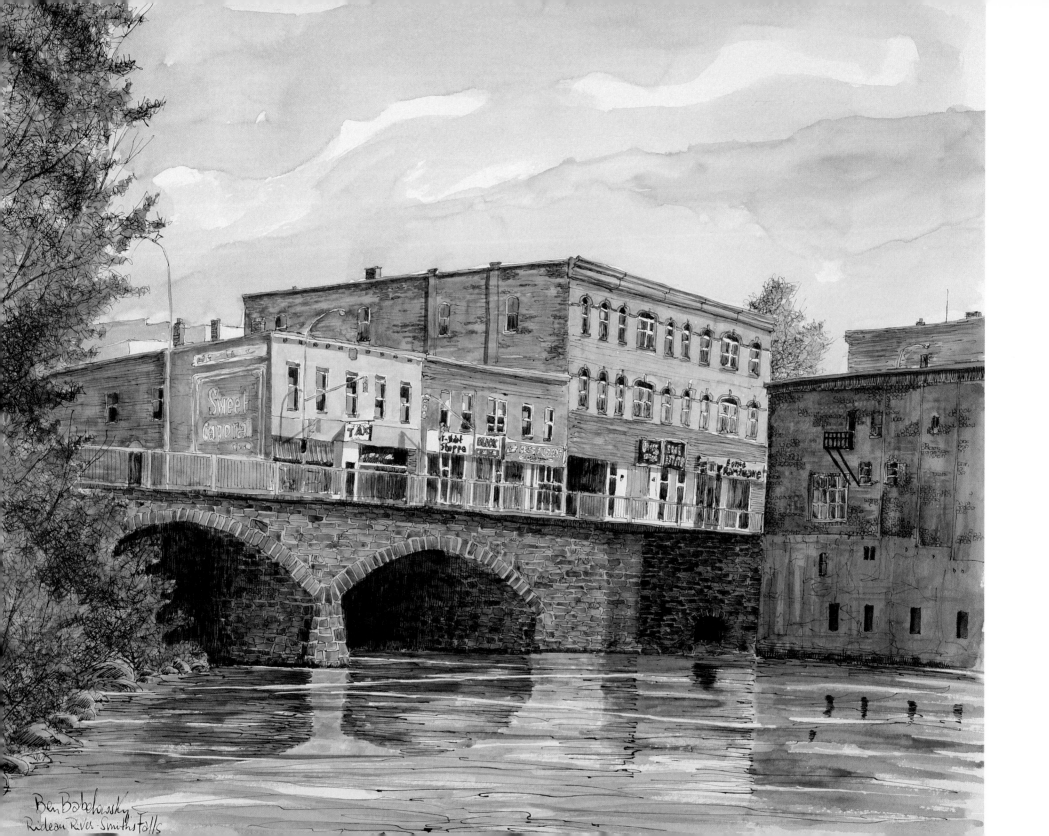

Ben Babelowsky
Rideau River - Smiths Falls

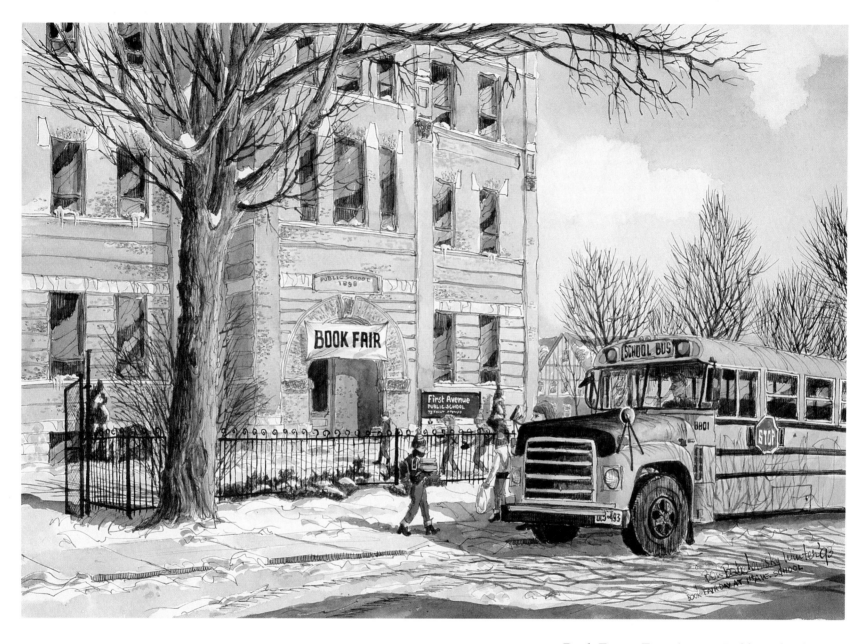

Book Fair at First Avenue Public School, 1993
Ink and watercolor
24" x 20"

Smiths Falls. Beckwith Street bridge over the canal, 1981

Ink and watercolor
24" x 20"

OILS AND ACRYLICS 1962–1976

◆　　　◆　　　◆

*While I have always enjoyed working with different media, my first love was
oil painting. The following pages show just a few from the Seventies —
these are all I have left. Gone are the mine scenes, the wildlife sketches
from the Sixties and the Muskoka scenes from the Fifties. I keep telling people
that I'll get back to oils one of these days.*

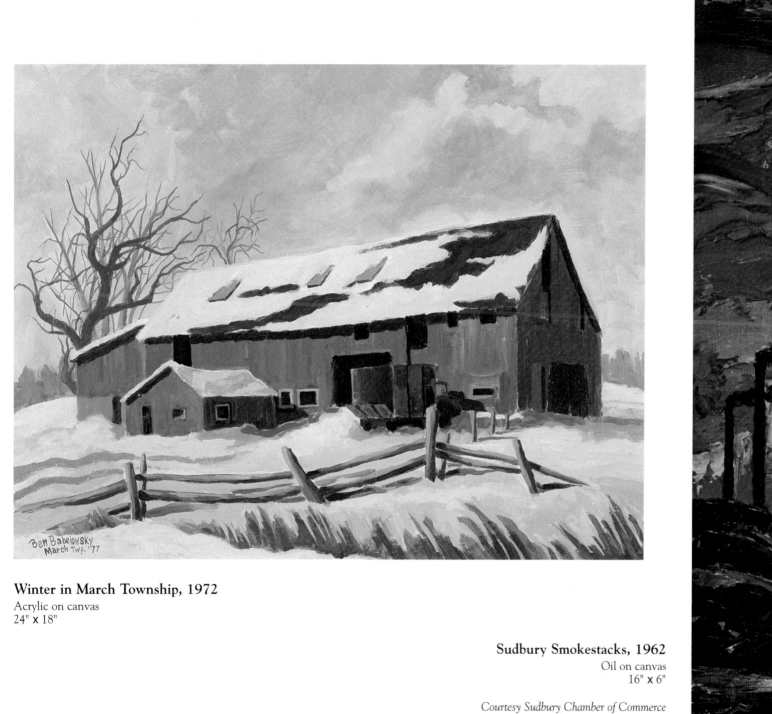

Winter in March Township, 1972
Acrylic on canvas
24" x 18"

Sudbury Smokestacks, 1962
Oil on canvas
16" x 6"

Courtesy Sudbury Chamber of Commerce

Creek, 1977
Oil on canvas
32" x 24"

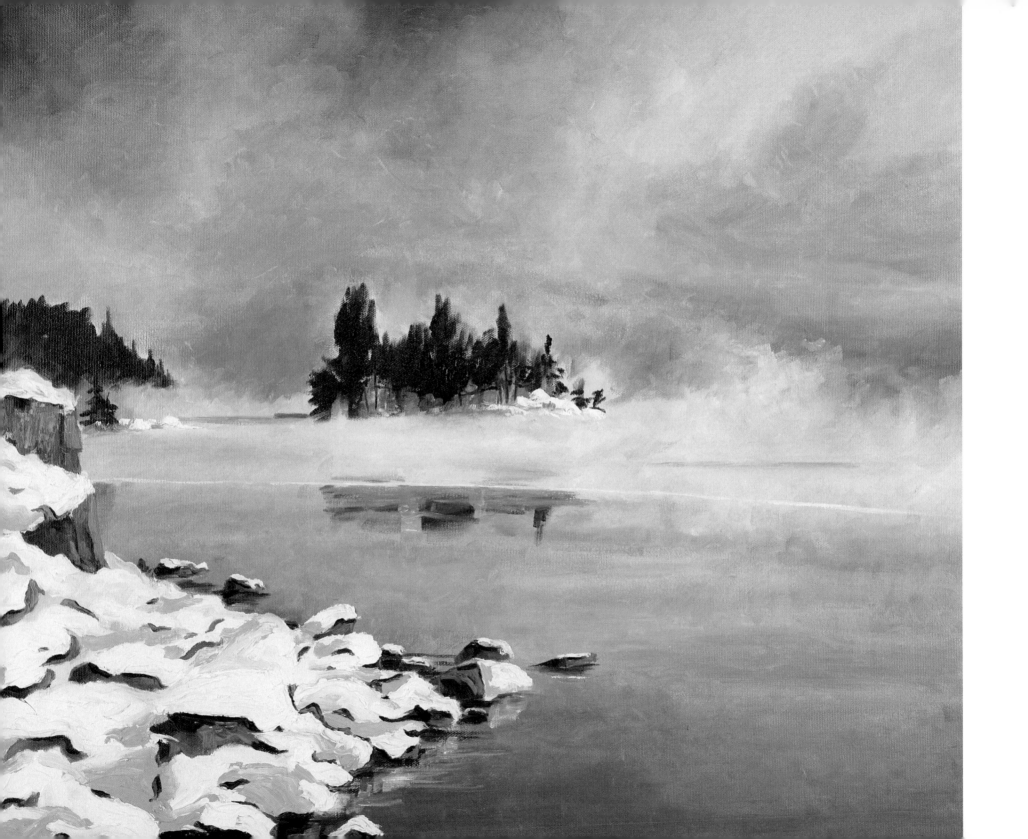

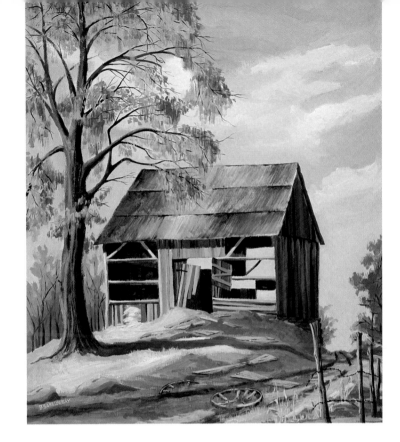

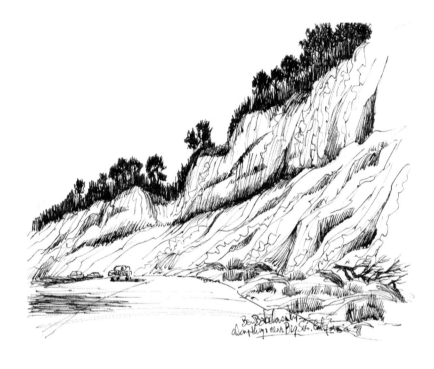

Barn, 1974
Acrylic on canvas
36" x 30"

**Winter on the
St. Lawrence, 1976**
Oil on Board
32" x 20"

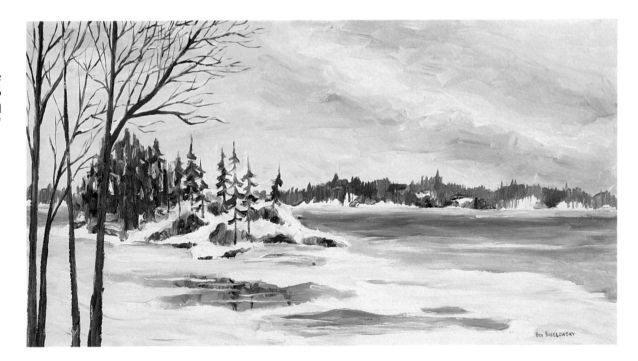

Winter on the St. Lawrence, 1978

Oil on canvas
24" x 20"

Courtesy Mr. and Mrs. Fred Dekker

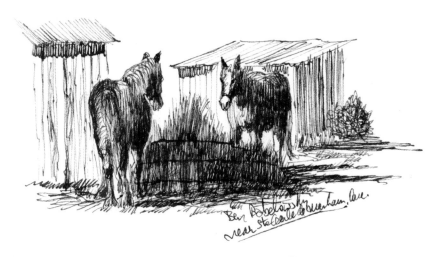

THE CITY AND THE COUNTRY

◆ ◆ ◆

Although I have taken painting and sketching trips to other parts of Canada, the U.S., Europe and beyond, the Valley is my home. For more than 30 years it has provided an inspiring environment with endless subject-matter worth sketching. I will never lose my love for it.

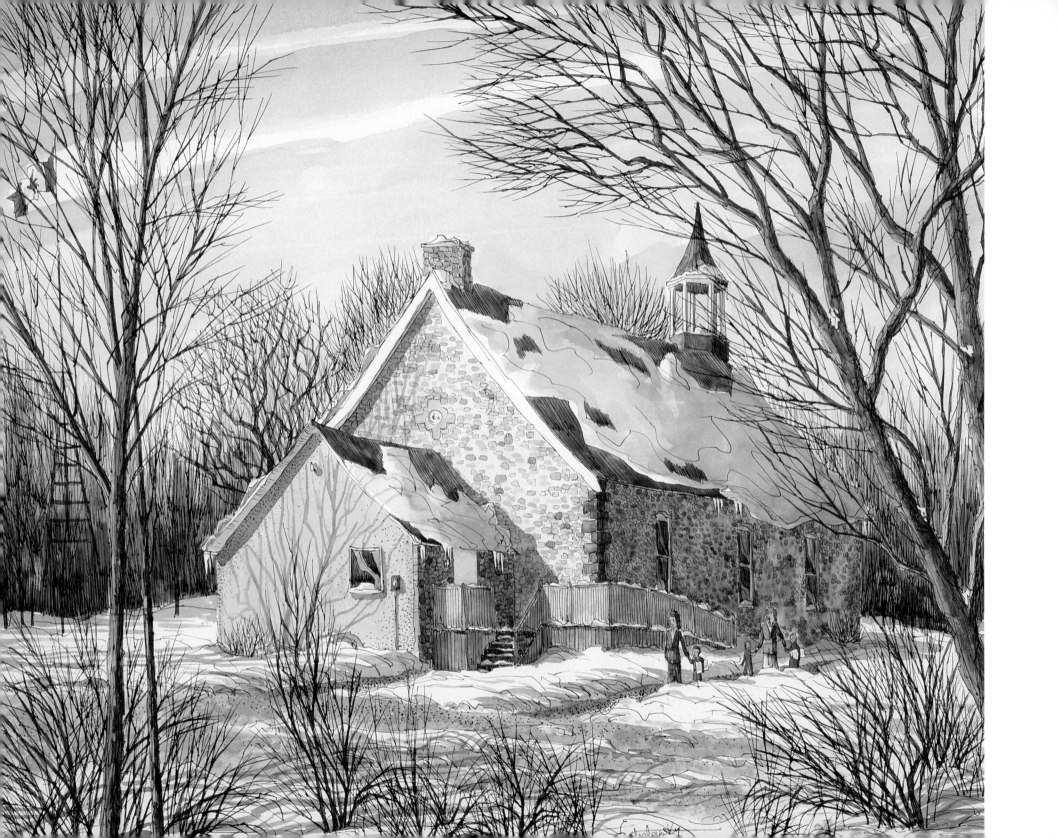

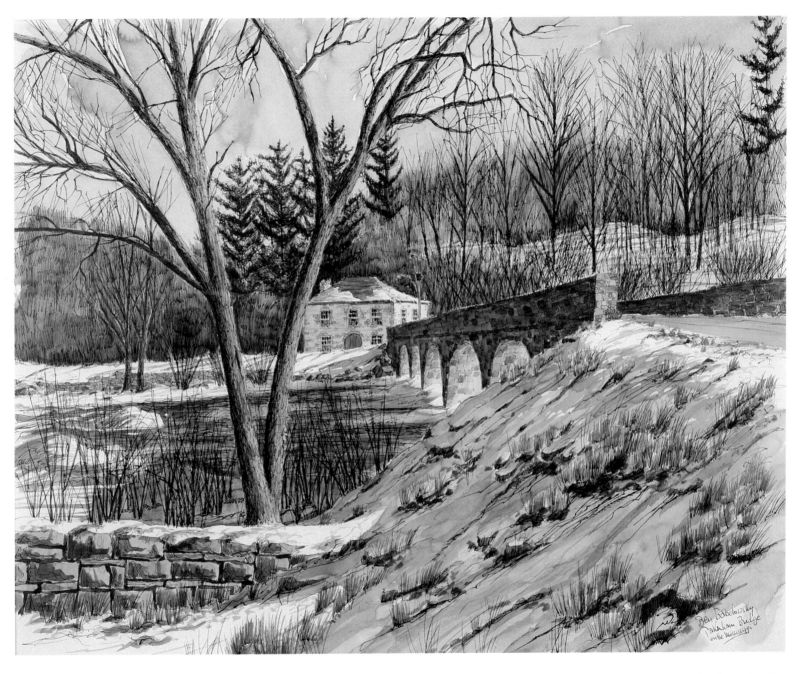

Pakenham Bridge
Ink and watercolor
30" x 24"

Courtesy Mr. and Mrs. Arthur Rice

Children's Art School, Kanata, 1988
Ink and watercolor
24" x 20"

Courtesy City of Kanata

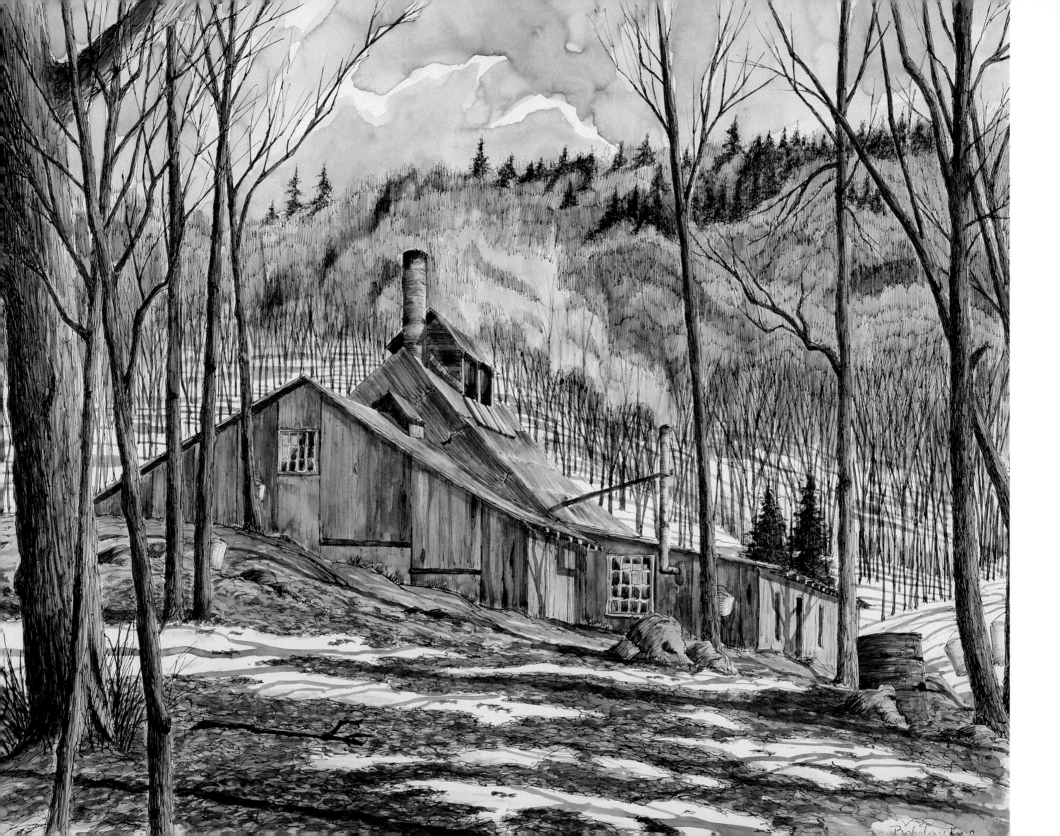

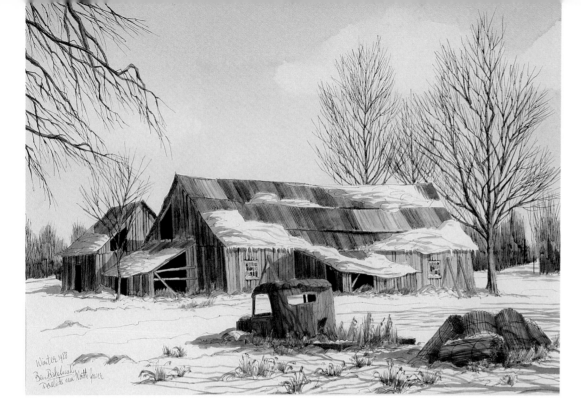

The Old Derelict, 1989
Ink and watercolor
30" x 24"

Courtesy National Printers Inc.

Along the St. Lawrence
Ink and watercolor
24" x 20"

Courtesy Mr. and Mrs. Ted Allan

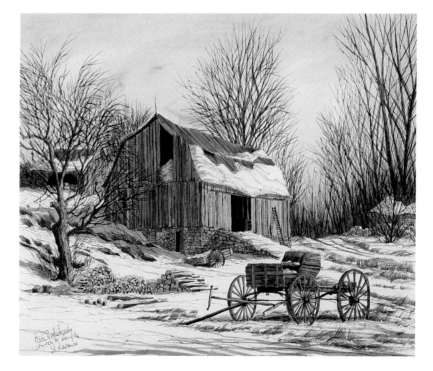

Sugar Shack in St. Cecile de Masham
Ink and watercolor
30" x 24"

Courtesy Mr. and Mrs. Bob Littlemore

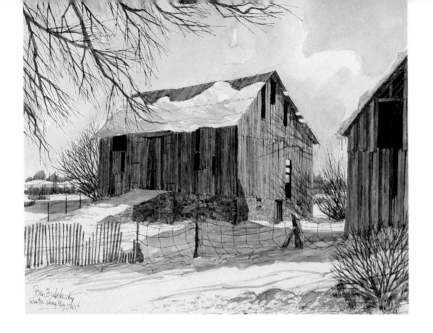

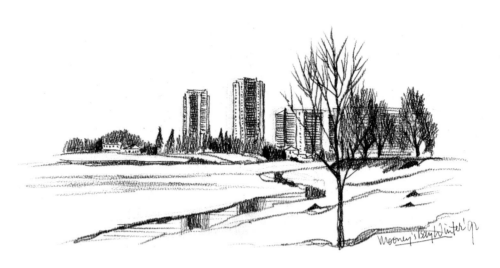

Barns near Nepean, 1988
Ink and watercolor
30" x 24"

Courtesy Mr. and Mrs. Arthur Rice

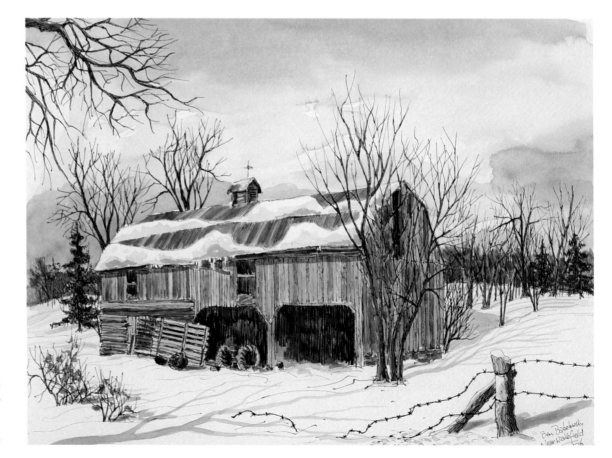

Near Wakefield, 1986
Ink and watercolor
20" x 16"

Courtesy Mr. and Mrs. Russ Mills

Ottawa Valley Winter

Ink and watercolor
30" x 24"

*Courtesy Perley-Robertson,
Panet, Hill and McDougall*

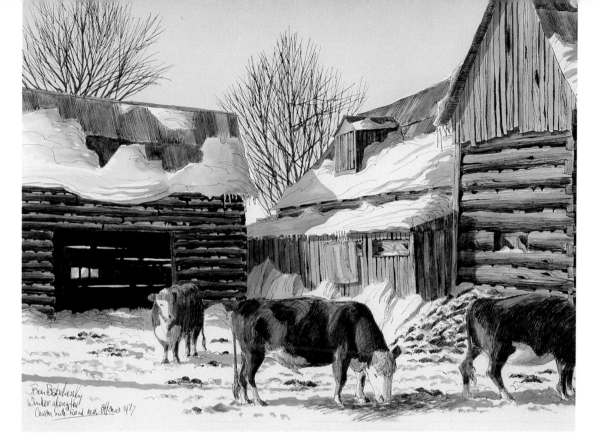

Winter in the Valley,
1986

Ink and watercolor
24" x 20"

Courtesy The Ottawa Citizen

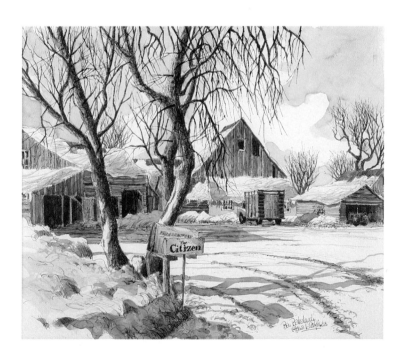

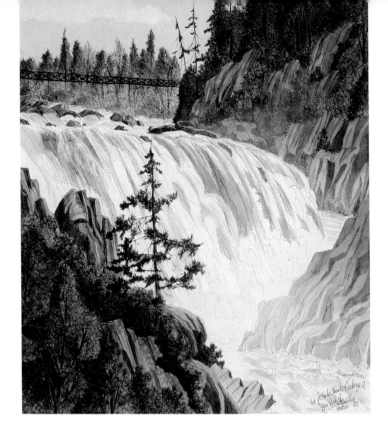

Coulonge River Falls, 1987
Ink and watercolor
24" x 20"

Courtesy Mr. and Mrs. George Toller

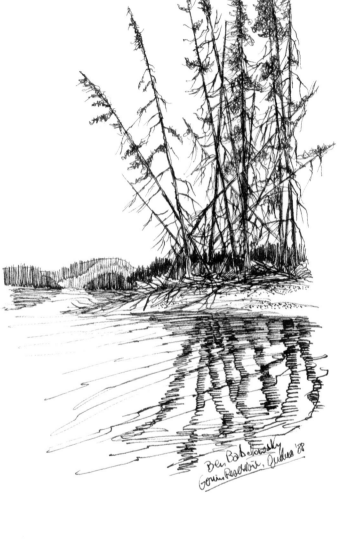

**Pinhey's Point,
Kanata, 1989**
Ink and watercolor
24" x 20"

Courtesy Wackid Radio

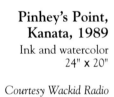

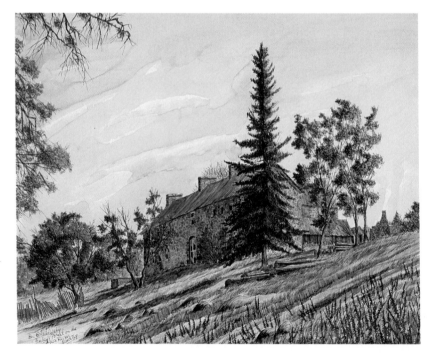

Wakefield Train
Ink and watercolor
30" x 24"

Courtesy Mr. and Mrs. George MacCabe

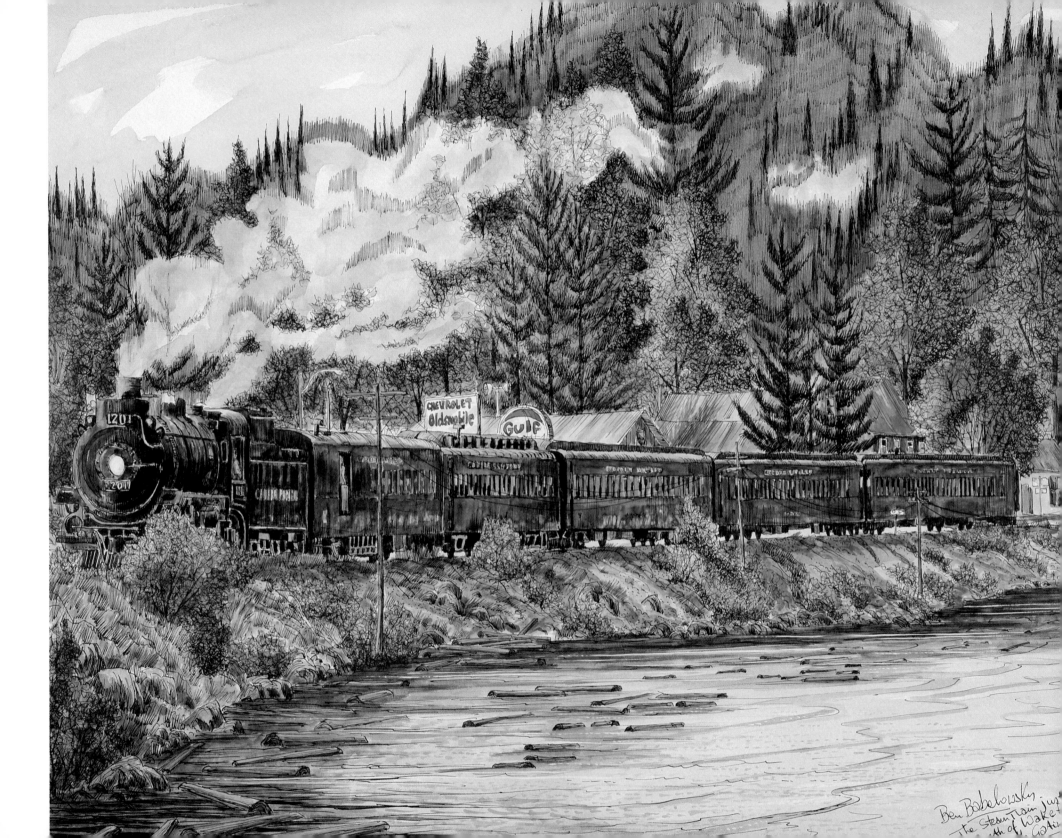

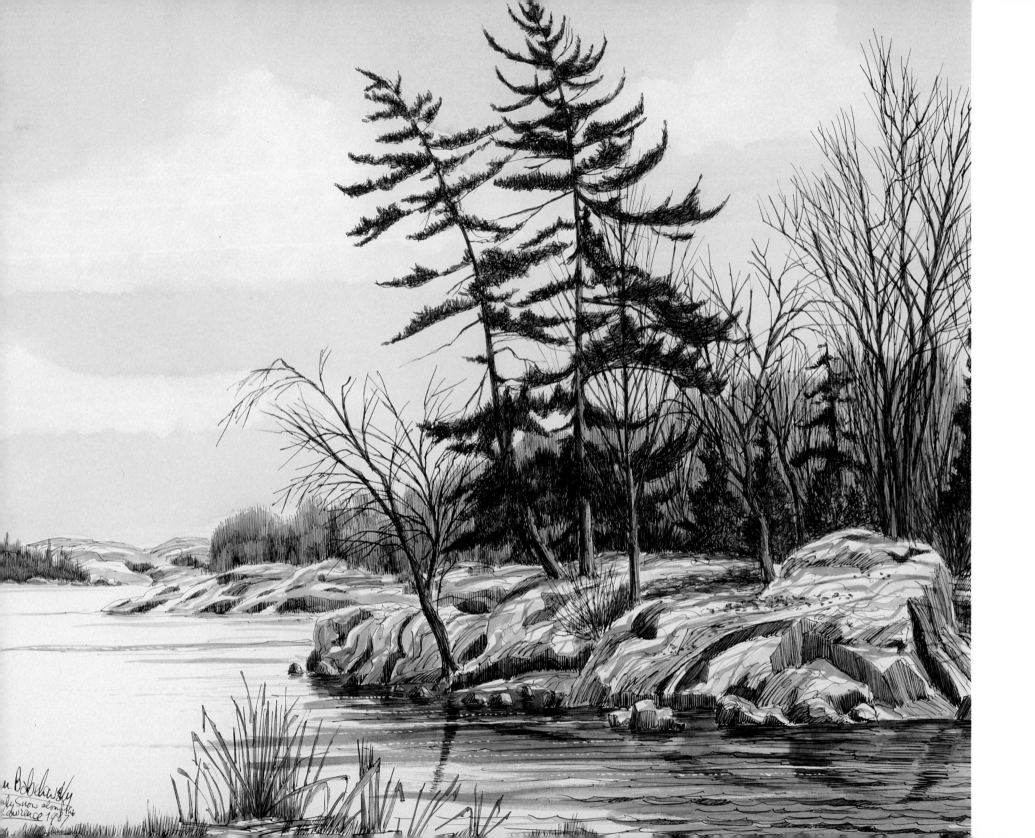

n B Lebedev
ly Snow along the
Lawrence 1987

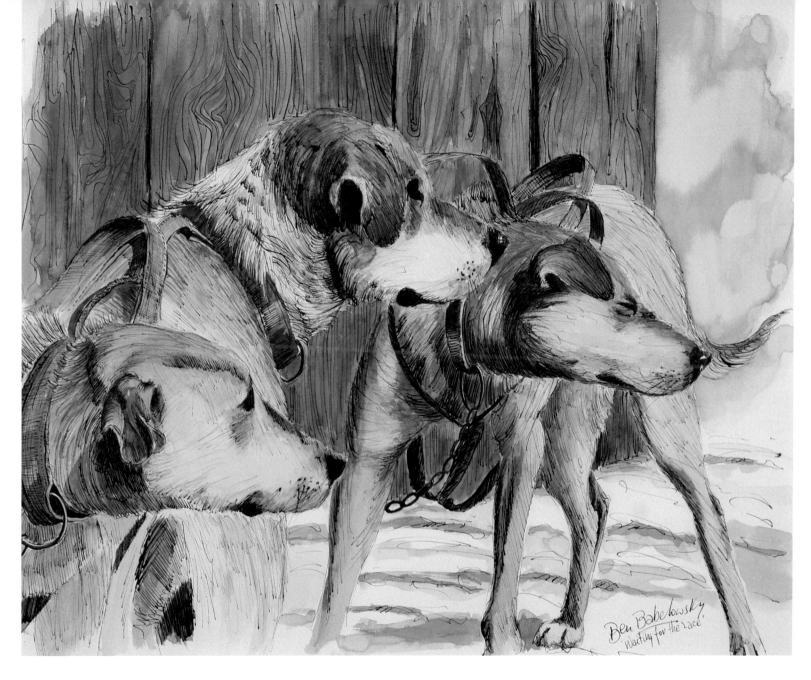

Waiting for the Race, 1982
Ink and watercolor
24" x 20"

Courtesy Mr. and Mrs. John Geleta, Jr.

Early Winter along the St. Lawrence, 1987
Ink and watercolor
30" x 24"

Courtesy Mr. and Mrs. Hank Dixon

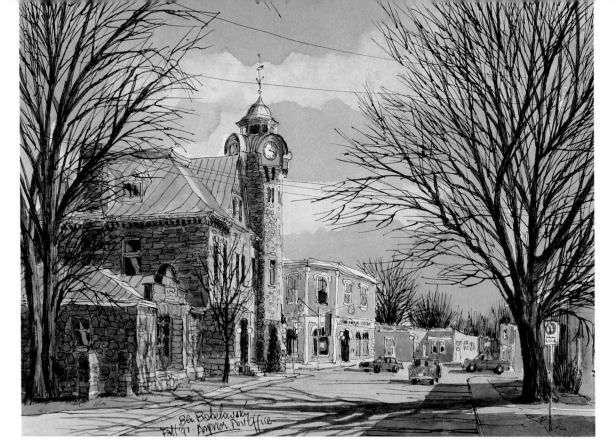

**Gillies Building,
Arnprior, 1992**
Ink and watercolor
15" x 11"

Courtesy Mrs. Jean Fuller

Along Highway 2
Ink and watercolor
30" x 24"

Courtesy Mr. and Mrs. Bill Jordan

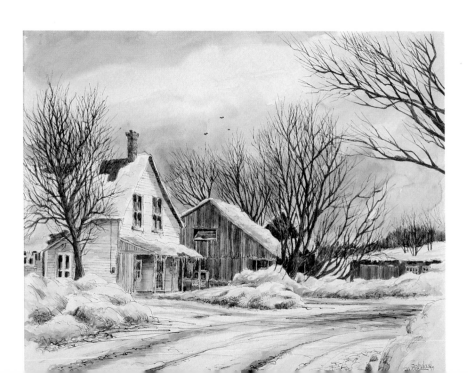

Somerset Street Corner Store, 1987
Ink and watercolor
24" x 20"

Courtesy Mr. and Mrs. Gus Pesoulas

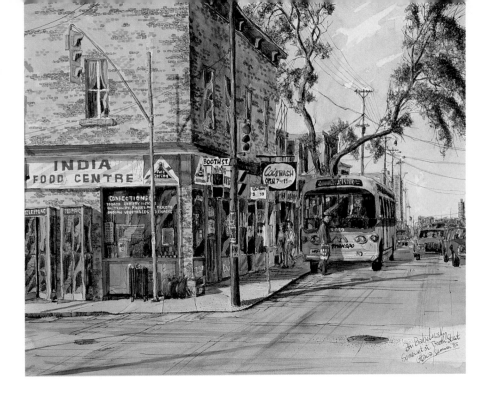

Along Elgin Street, 1988
Ink and watercolor
24" x 20"

*Courtesy Mr. Sandy Smallwood
(Andrex Holdings Ltd.)*

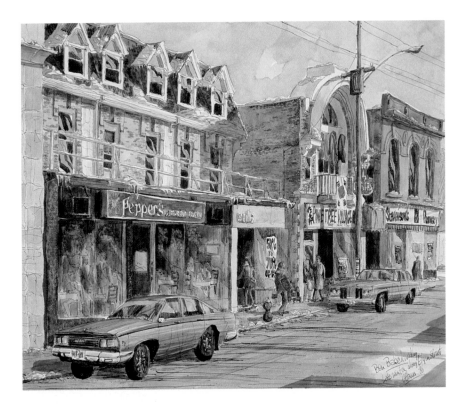

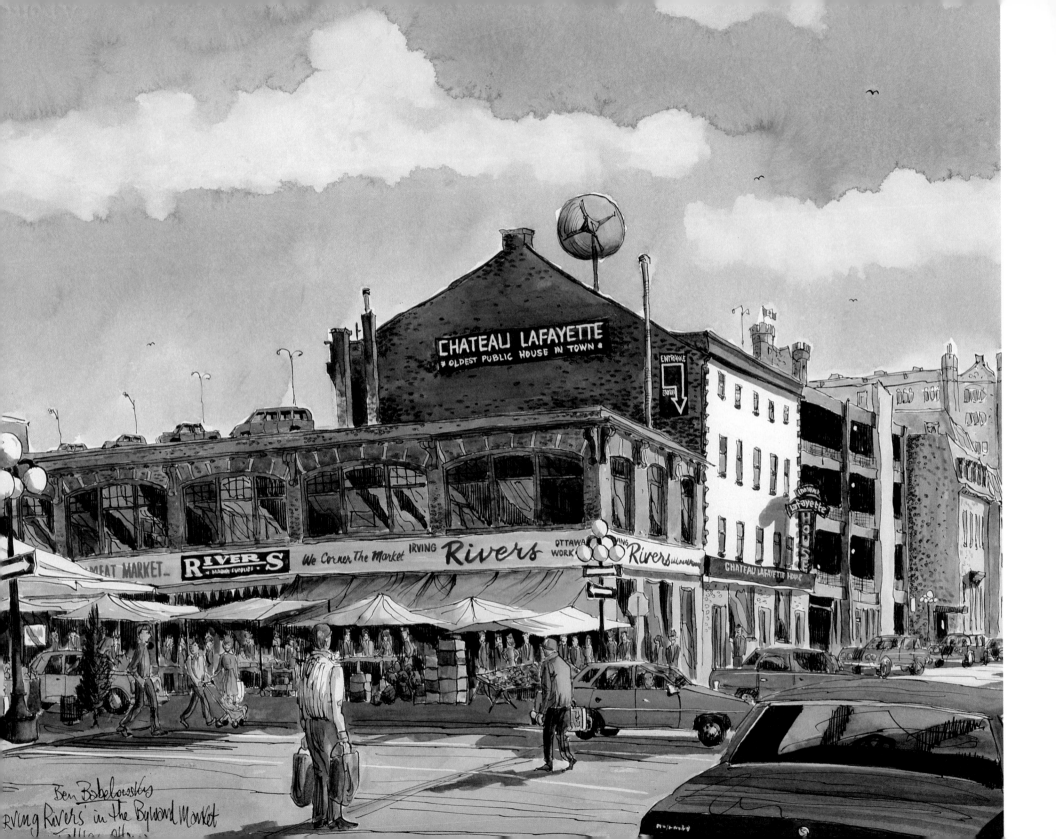

CHATEAU LAFAYETTE
* OLDEST PUBLIC HOUSE IN TOWN *

ENTRANCE

RIVER S
MEAT MARKET
We Corner The Market IRVING Rivers OTTAWA Rivers

Ben Babelowsky
rving Rivers' in the Byward Market

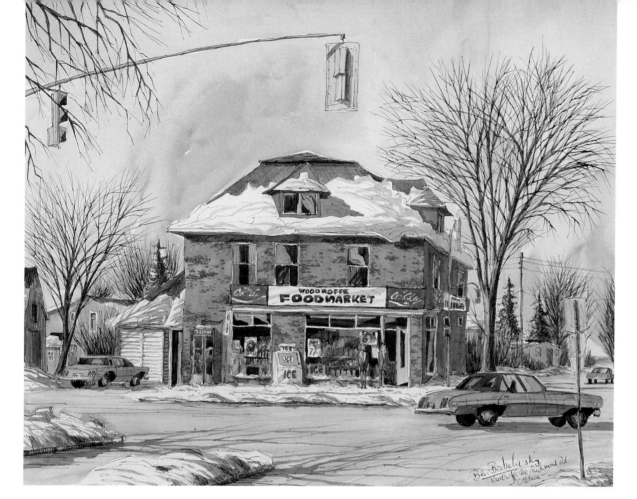

Woodroffe Corner Store, 1986
Ink and watercolor
24" x 20"

Courtesy Mr. and Mrs. Gus Pesoulas

Looking Across Wellington Street, 1989
Ink and watercolor
30" x 24"

Courtesy National Printers, Inc.

Byward Market, 1992
Ink and watercolor
30" x 24"

Courtesy Mr. and Mrs. Irving Rivers

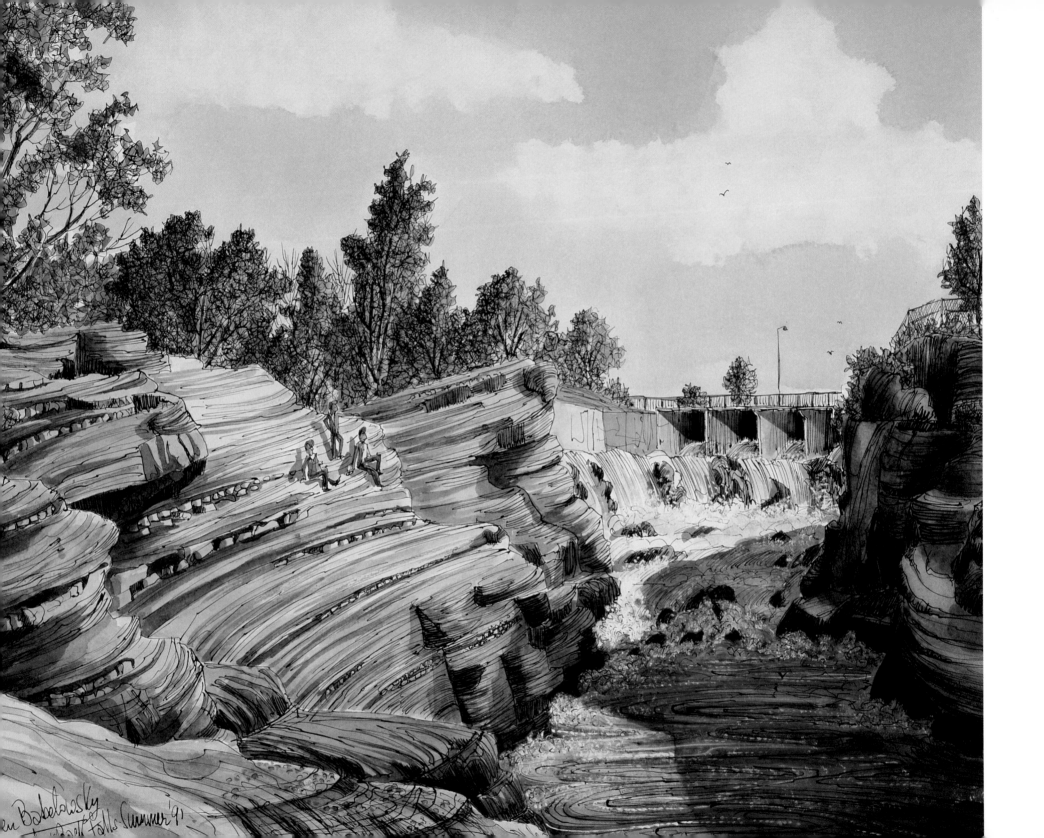

Ian Babalowsky
Falls Summer '91

Bank Street Bridge over the Canal, 1993
Ink and watercolor
24" x 20"

Courtesy Regional Municipality
of Ottawa-Carleton

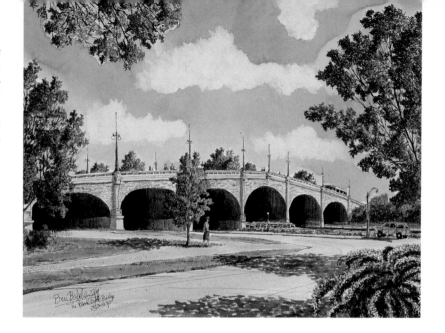

Where the Rideau Canal joins the Ottawa River, 1989
Ink and watercolor
24" x 20"

Courtesy Mr. and Mrs. Rudy Gittens

Hog's Back Falls, 1992
Ink and watercolor
24" x 20"

Courtesy Mr. and Mrs. Howard Darwin

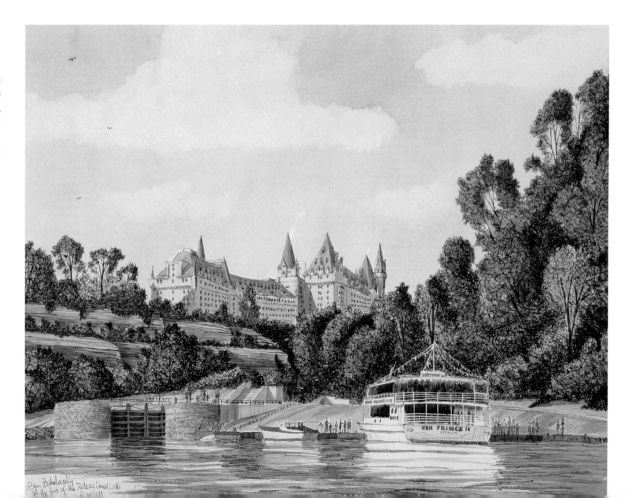

103

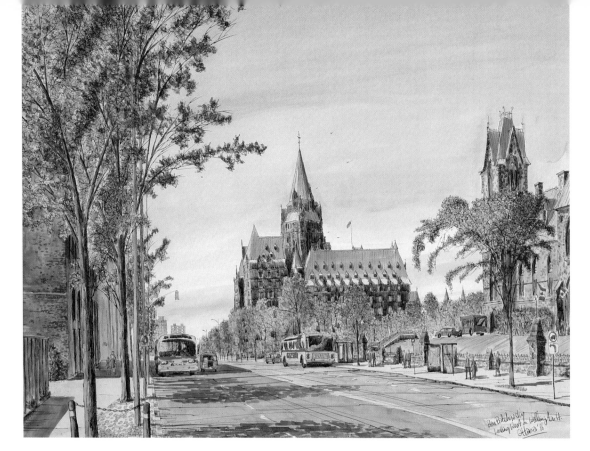

Wellington Street, 1990
Ink and watercolor
30" x 24"

Courtesy Mr. and Mrs. John Geleta, Sr.

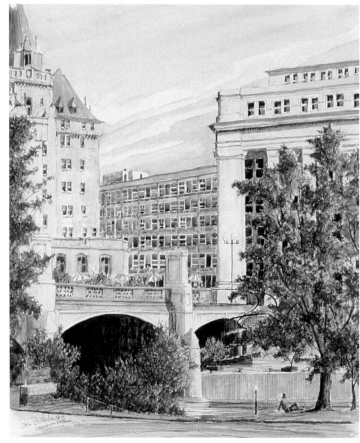

**Looking Across the
Canal, 1984**
Ink and watercolor
24" x 20"

*Courtesy City of Ottawa Art
in Public Places Collection*

**The Fuller Residence
on the Ottawa River,
1986**

Ink and watercolor
24" x 20"

Courtesy Mrs. Jean Fuller

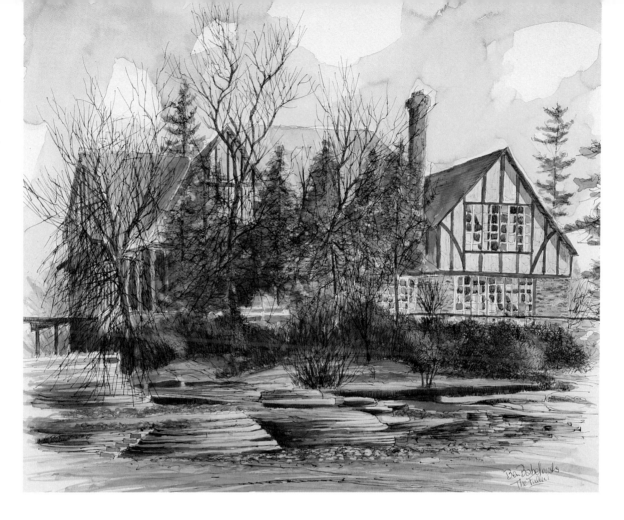

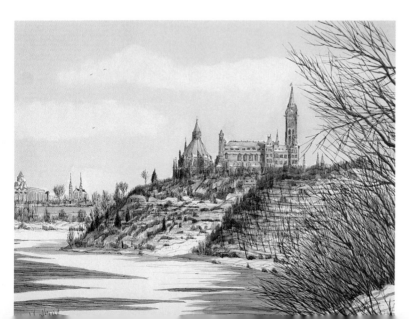

Parliament Hill in Winter, 1990

Ink and watercolor
24" x 20"

Courtesy Glenview Corporation

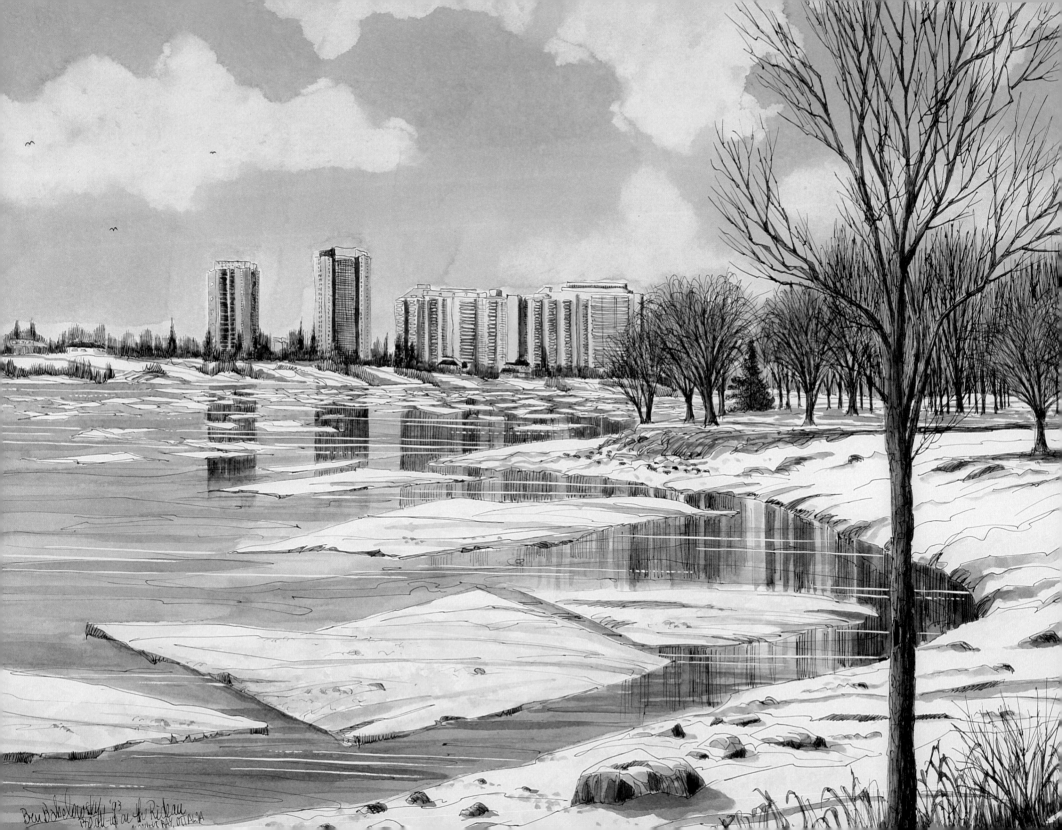

Ben Babelowsky '93 Break-up on the Rideau
Mooney's Bay, Ottawa

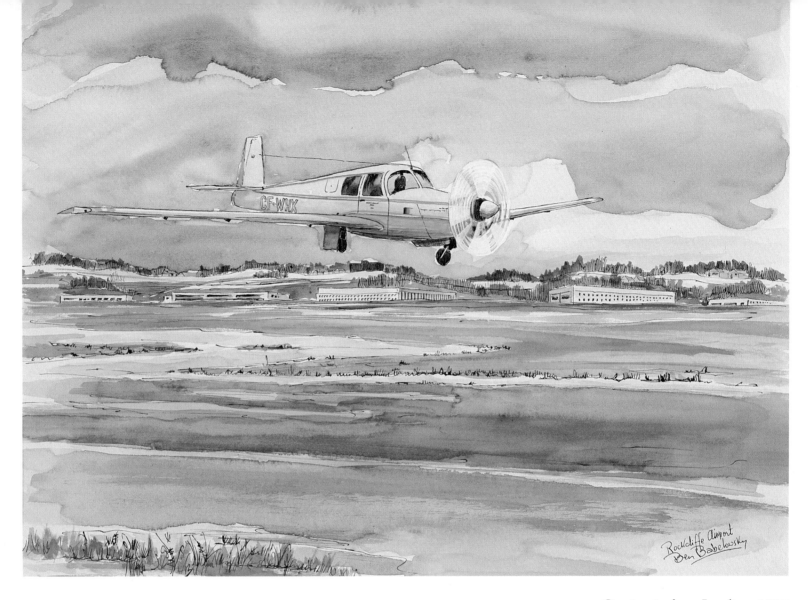

Coming in for a Landing, 1981
Ink and watercolor
20" x 16"

Courtesy Mr. and Mrs. Cam McNeil

Ice Breakup at Mooney's Bay, 1993
Ink and watercolor
30" x 24"

Courtesy Mr. and Mrs. Rudy Gittens

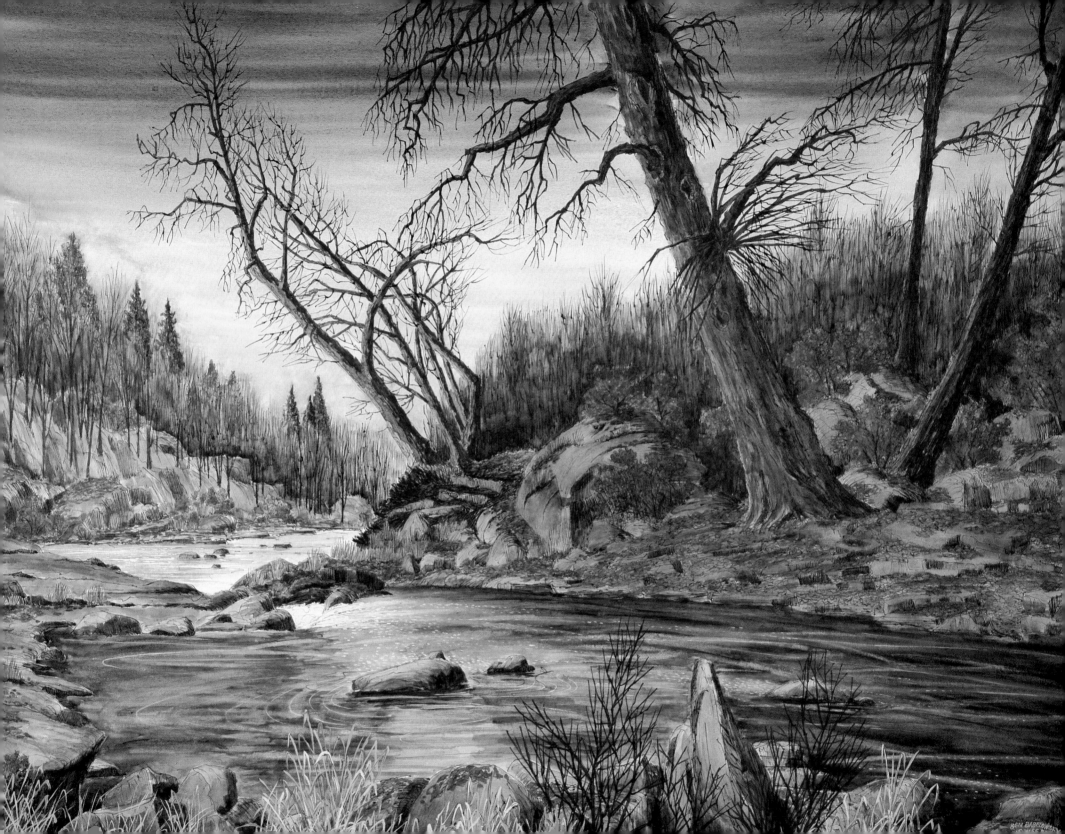

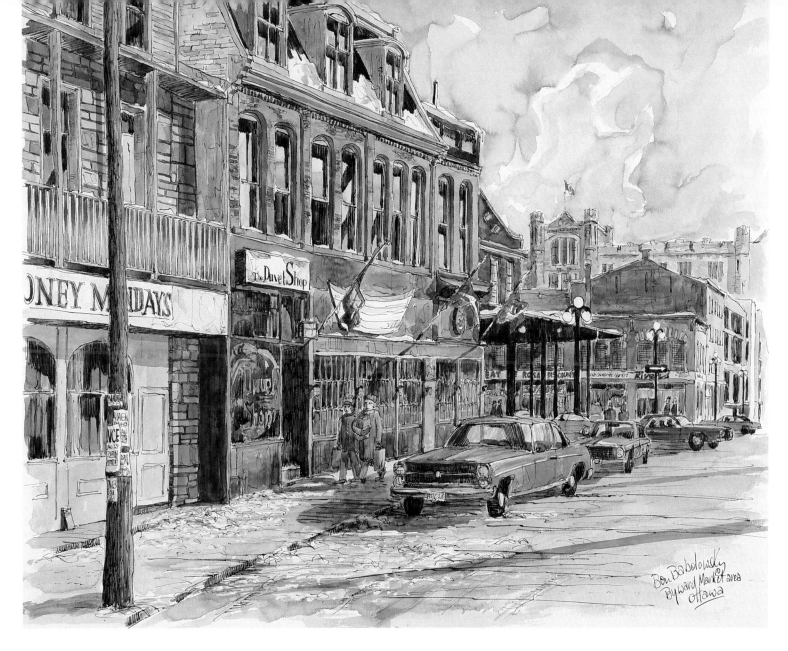

In the Byward Market, 1980

Ink and watercolor

Courtesy Hadwen Imaging Technologies

Bonnechere River, 1993

Sepia Ink and watercolor
40" x 30"

Fog in the Rockies '85
West of Calgary near Canmore

BEYOND THE VALLEY

◆　　　◆　　　◆

*Now that retirement offers me more time to travel, my sights are set
on different locales. I'm almost always drawn to water. The Maritimes,
the New England states — oceans, rivers and lakes hold a never ending
fascination for me. But then there's the West Coast and I do love mountains.
And of course Canada has lots of great cities with those street scenes I love
to paint. And I've never painted in the Prairies …*

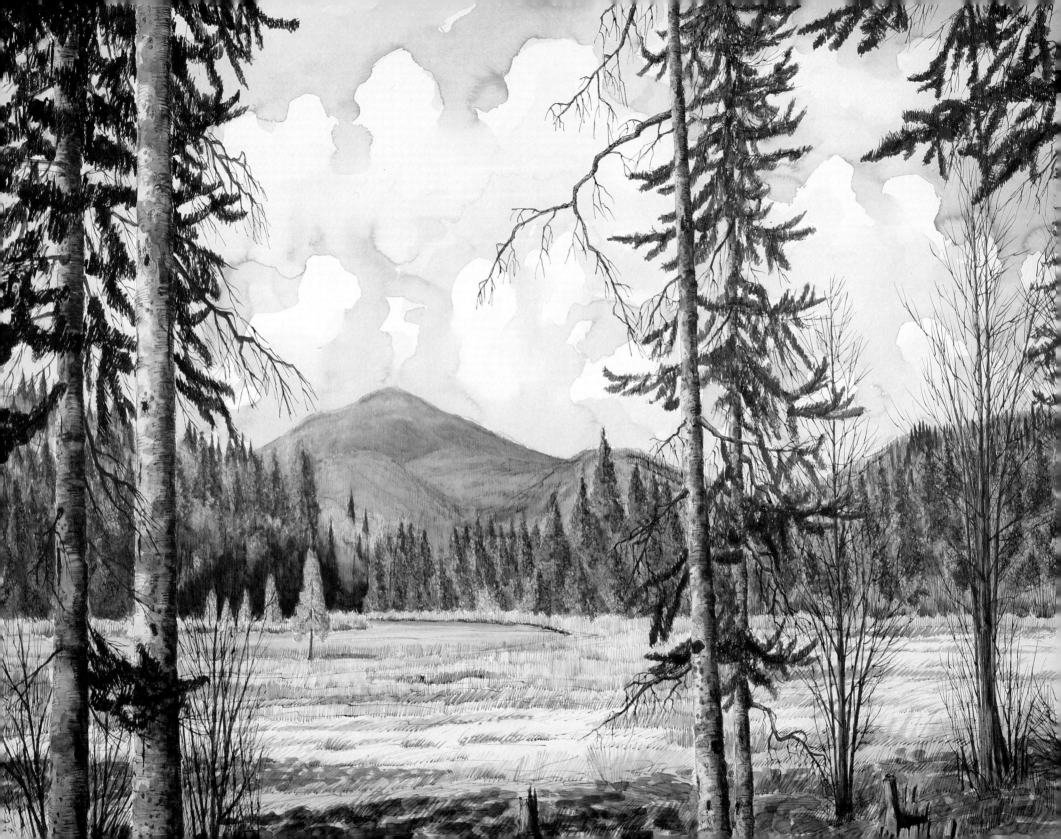

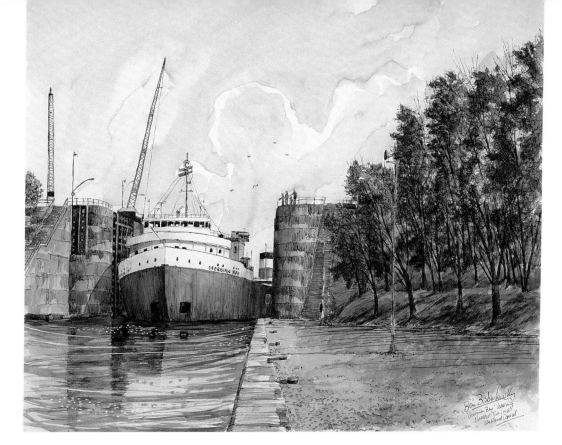

"Georgian Bay" leaving number two lock, Welland Canal, 1986
Ink and watercolor
24" x 20"

Courtesy St. Catharines Standard

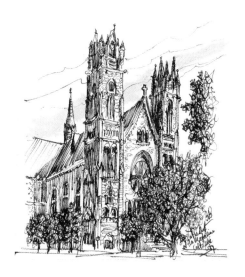

Maid of the Mist, Niagara Falls 1986
Ink and watercolor
24" x 20"

Courtesy St. Catharines Standard

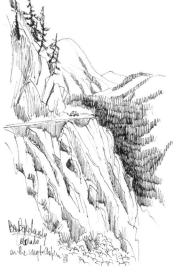

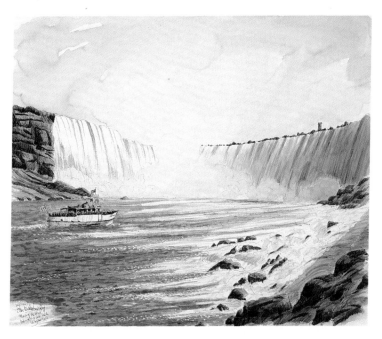

Whiteface Mountain, Spring, 1993

Sepia Ink and watercolor
40" x 30"

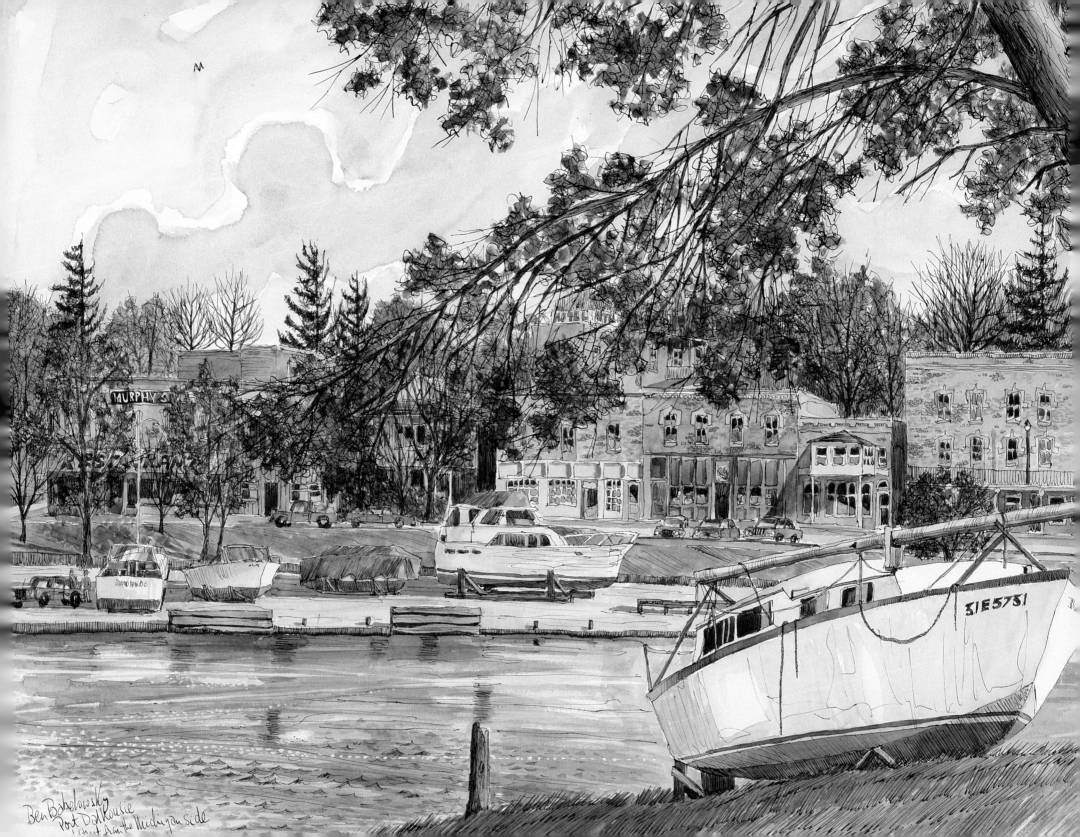

Ben Babelowsky
Port Dalhousie
(short run the Michigan side

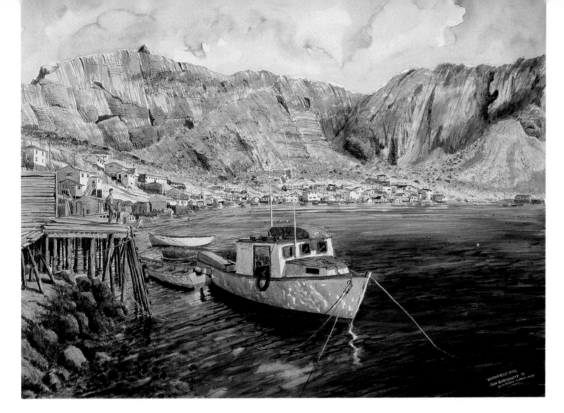

Herringneck, Newfoundland, 1993
Sepia Ink and watercolor
40" x 30"

(with thanks to Malak)

Portland, Maine Lighthouse, 1993
Sepia Ink and watercolor
40" x 30"

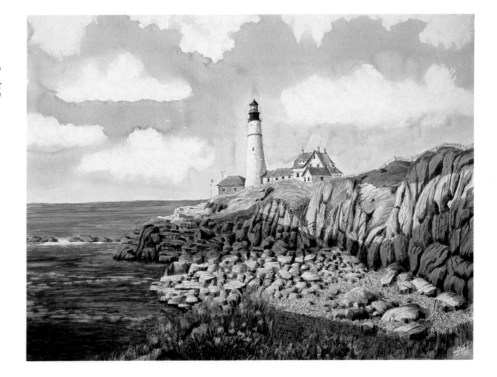

Port Dalhousie from the Michigan side, 1986

Ink and watercolor
24" x 20"

Courtesy St. Catharines Standard

FROM MY TRAVEL SKETCH BOOK

◆ ◆ ◆

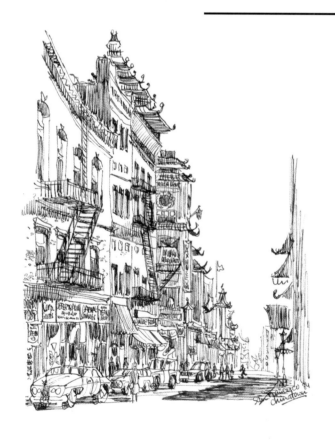

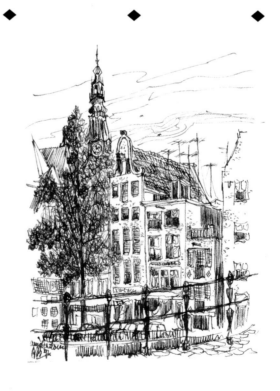

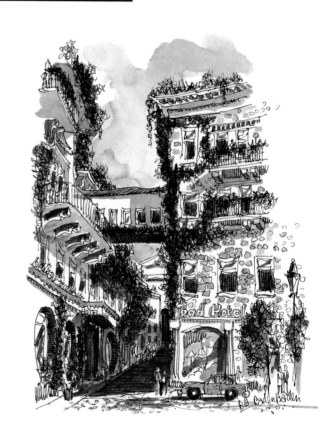